IMAGES
of America

MIDLAND
HER CONTINUING STORY

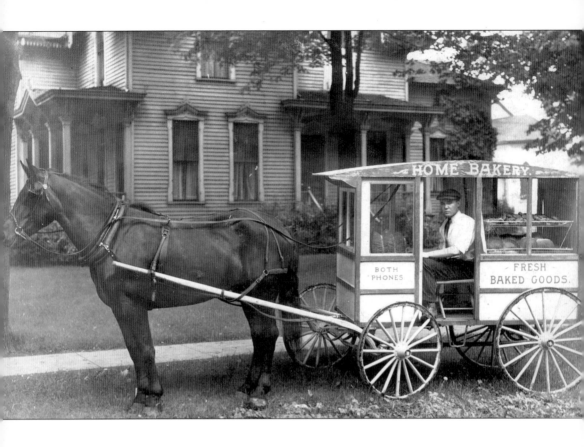

IMAGES
of America

MIDLAND
HER CONTINUING STORY

Virginia Florey
Edited by Leona Seamster

ARCADIA
PUBLISHING

Published by Arcadia Publishing
Charleston SC, Chicago IL, Portsmouth NH, San Francisco CA

Printed in the United States of America

Library of Congress Catalog Card Number: 2002111102

For all general information contact Arcadia Publishing at:
Telephone 843-853-2070
Fax 843-853-0044
E-mail sales@arcadiapublishing.com
For customer service and orders:
Toll-Free 1-888-313-2665

Visit us on the Internet at www.arcadiapublishing.com

Dedication

This book is dedicated in loving memory of my father Gil Merritt (on the left) and Leona's father Frank Clark (on the right). Frank and Gil were friends for years. Both men loved the simple life, were great readers, loved music, and made fatherhood an important part of their adult life. In 1976, Frank Clark published a book of his poetry entitled *Everything is Beautiful* and gave a copy to my father. The inscription reads: "Gil: Whether in the boiler shop or in the Barstow Room, all bring fond memories, and memories, too, are beautiful." The boiler shop refers to where they were employed at Dow, and the Barstow Room refers to where they met to talk and play pool after they retired. Frank Clark died in 1979. Gil Merritt died in 1990. Our greatest inheritance is their love.

CONTENTS

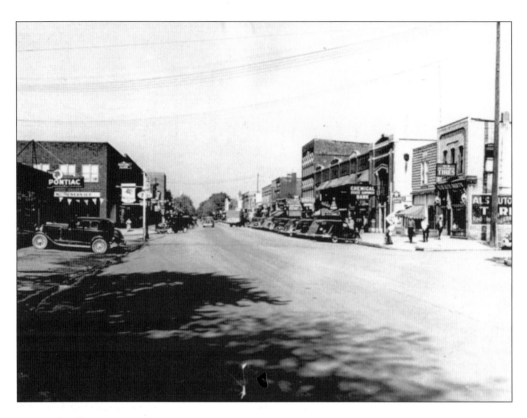

ACKNOWLEDGMENTS

Do you usually skip over the acknowledgments when you begin a new book? We hope not, because this book could never have come to fruition without the help of many people. We are eternally grateful for the help so many have given us in our search for pictures. Without photos there would be no book. So here goes. We gratefully acknowledge Jack Telfer, editor of the *Midland Daily News*, and Doug Winger, librarian of the *Midland Daily News*, both of whom saved us hours of research by allowing us the use of their archives. Special thanks as always to Kathy Thomas and Ned Brandt of the Dow Archives who managed to magically come up with just what we wanted. Words can't express how much help we received from Galen Gransden of Edenville, who related the history of early Edenville, or from Allen Cole of Sanford, who also told us stories about the pictures loaned by Nancy Lackie of the Sanford Historical Museum. A thank you to Gary Skory for allowing us the use of the Midland Historical Society's archives for photos, to Amy Lindesmith for her ability to take old, beat-up photos and magically turn them into quality pictures, and to Glenn Roberts for his help at the beginning of our search for a cover and for many of his photos taken while he was chief photographer at the *Midland Daily News*. Many thanks to Donna Rapp and Leeza Bacon of the MidMichigan Regional Medical Center for the early photos of the Midland Hospital. Our sincere appreciation to all those who so willingly shared photos to help us tell the continuing story of Midland. And last of all, a heart-felt thank you to Maura Brown, our editor at Arcadia, for her generous help all along the way in getting this book into print.

INTRODUCTION

When we put together our first book, *Midland: The Way We Were*, we did it as a labor of love. We wanted to honor the small town where our roots had been planted.

My great-grandfather, Henry White, came here in 1869. A veteran of the Civil War (he served in the New York Infantry), Henry, his wife, Elmira, and two sons followed his daughter Emma to the small Village of Midland City. In 1865, Emma had married George Covert, who was employed in the woods scaling timber in the thriving lumber camps of Averill, Edenville, and Hope—all located in Midland County. When Elmira died in 1870, Henry White married Catherine Coty, and their only child, my maternal grandmother, was born in Midland on June 26, 1872.

Leona's family's roots in Midland County begin at approximately the same time with records showing that her grandmother, Luella Hubbell, was born in Michigan on April 9, 1869, the same week that the Village of Midland City came into existence with its new name. By 1872, Luella's father, Samuel Hubbell, his wife, Lorinda, and their children were the second family to relocate in Warren Township. At that time, the railroad reached only as far as Alamando Road, and so a team of oxen hauled their goods to Coleman. Samuel Hubbell was the first supervisor for Warren Township, serving from 1873 to 1876.

Both Henry White and Samuel Hubbell came to Midland from Chemung County in New York. Did they know each other? Did a mutual friend write them to tell them about this new state of Michigan and the possibilities that existed here? Did they listen to a real estate dealer promising much land for little money and endless prosperity? We'll never know. We do know that several families came to Midland County from Chemung County at the same time; one of them was Sylvester Erway, who chose to settle in Hope. We only know that they came to make their home here and that their children and grandchildren and great-grandchildren have continued to call Midland their home.

Here are some of the things that we didn't cover in our first book: the many local foundations that have given the small town of Midland the advantages of a cosmopolitan center; the emergence of Midland from its early lumbering days to its present industrial eminence; the development of the Circle originally platted as Dagle's Corners by Anthony Dagle; the slow but steady progress in our recreational facilities; and the change in the people themselves as our society slowly grew from an agrarian society to a more sophisticated industrial society.

Though Midland has changed greatly from her humble beginnings in 1837, when the first settlers arrived, to the present-day 21st century, the quintessence of the town has remained the same. Quintessence as defined by Webster's Dictionary is "the most perfect embodiment of something." To us who have spent our lives in Midland, she is indeed the perfect embodiment of what we cherish most.

Here, then, is our second book on the little town of Midland: *Her Continuing Story*.

THE U.S. 10 CORRIDOR
An Introduction

There were giants in those days ... men of renown.

—Genesis 6:4 KJV

If there were no one to record it, history would still be made. If no one had ever recorded the lumbering era in Michigan, still the story of the white pine and the lumberjacks who cut that white pine down would have existed and become a part of history. And never more so than in Midland County, where the towns of Averill, Sanford, Hope, Coleman, and Edenville played out their part in Michigan's logging boom. Today these five villages remain as reminders of the lumbering saga that swept through Michigan from about 1850 to 1910.

When the lumber barons from the East saw the white pine covering Michigan, they said that there was enough timber to last 500 years. But in less than 50 years, the white pine was decimated. New machinery, new methods, and greed hastened the end of the lumbering industry in Midland County. The lumber barons moved on to more lucrative fields, leaving behind land covered with stumps and "slash" that fueled forest fires, burning whole towns . Still, the little towns of Averill, Sanford, Coleman, Hope, and Edenville had their moment in history. Stan Berriman wrote in his great book, *Upper Tittabawassee River Boom Towns*, "The best of Michigan pine, both in quality and quantity, came from the central portion of the lower peninsula which included the Sanford, Hope, Averill, and Edenville areas. These areas included not only the majestic white pine, but interspersed with them were hardwoods of oak, maple, beech, cherry, and elm as well."

Averill eventually became home to the world's largest rollway for logs and for awhile earned the nickname "Red Keg." Sanford, two miles up the road, supplied men and equipment for the camps that sprouted up overnight as men sought to cash in on the timber boom. Sawmills, stores, hotels, and cheap labor made Hope and Edenville (saddled with the name of Camp Sixteen) prosperous, as lumberjacks, sawyers, and all the accompanying resources needed in a lumber camp stretched in their direction. Coleman, though not on the Tittabawassee River and therefore less suited for lumber camps, was important as a supplier of men and materials for the thriving lumber business. By 1870, the Flint and Pere Marquette Railroad had reached Coleman, making it an important link in getting the timber from the woods to the Tittabawassee River and on to the sawmills in Saginaw and East Saginaw.

This, then, is a short history of the lumbering era in Averill, Sanford, and Coleman—three villages linked by the U.S. 10 corridor, and Hope and Edenville—two villages near the almighty rivers that saw logs guided in their final destination to the huge sawmills in Saginaw, Michigan.

One

THE U.S. 10 CORRIDOR

AVERILL, SANFORD, AND COLEMAN

AVERILL

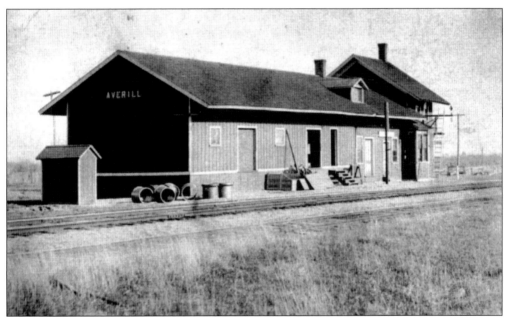

By 1875, a banking ground was established at Averill's Station. Lumbermen sent their logs down on the Flint & Pere Marquette Railroad to be banked until the flood waters in the spring sent them to the sawmills in Saginaw and East Saginaw. But the next year, 1876, a fire devastated Averill's Station. Three years later, only 35 hardy souls had decided to stick it out and hope for better times. Those better times arrived in 1881, when Wright and Ketchum scouted the region for use as a banking ground, and lasted until about 1887. That year was the turning point of the lumbering boom. The tall timber was gone and so were the lumber barons and the lumberjacks. By 1889, only the railroad depot, a general store, and a post office remained in operation in Averill.

By 1868, the Flint and Pere Marquette Railroad had put in six and a half miles of track from Midland to rail's end. Then they had to find someone to run the station and the telegraph key, which was vital for communication at that time in our history. A man named Harrison Averill was chosen for the job, and the area subsequently became known as Averill's Station. A post office was set up and Averill became the first postmaster along with his other duties.

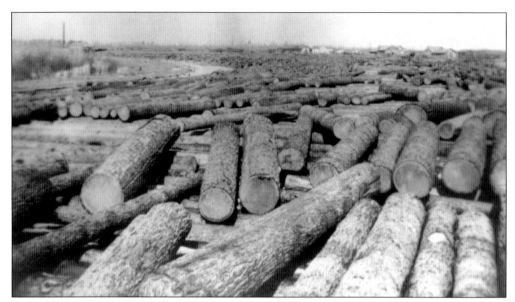

AVERILL ROLLWAY. The rollway in Averill was the largest in the world because the perfect juxtaposition of land and water occurred there. As the Tittabawassee River entered Averill, it dipped to the south for a mile and then went east toward Midland. The Flint & Pere Marquette railroad tracks acted as a hypotenuse forming a rough triangle. One year, the rollway contained 21.5 million feet of logs. (Photo courtesy of Nancy Lackie, Sanford Museum.)

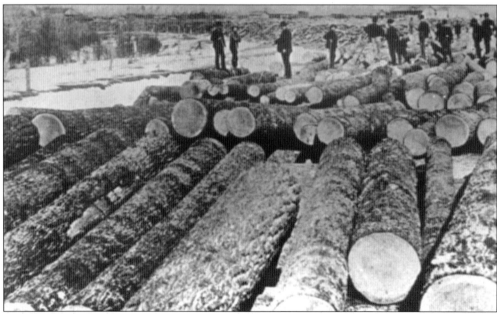

THE LUMBER BARONS. In 1875, 300 lumber barons attended a convention in Columbus, Ohio, and from there were taken by train to Averill's Station to see the banking ground. A banking ground or rollway was the place where the timber cut all winter long was stored until the spring thaw. Work ended in the winter because there was no way to get the logs out of the woods until the first narrow gauge railroad was built; then timber could be cut all year round. (Photo courtesy of Nancy Lackie, Sanford Museum.)

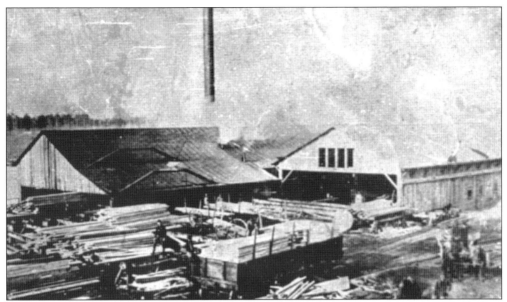

ZIMMERMANN SAWMILL (AVERILL). Records show that August Zimmermann of Averill ran a sawmill from 1911 to 1915. Sawmills did not play a huge part in the history of Averill, Hope, Sanford, Coleman, and Edenville. It was easier to send the logs down the river to Saginaw to the sawmills there. Many times small sawmills sold out to large firms, such as Wright & Ketchum, or became shingle mills. (Photo courtesy of Nancy Lackie, Sanford Museum.)

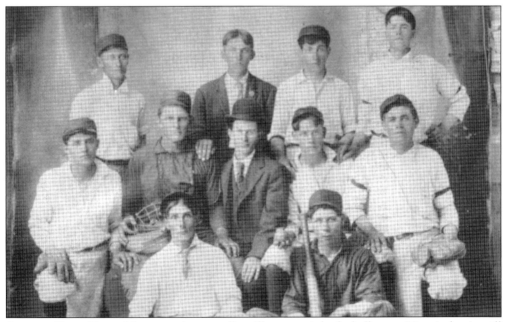

AVERILL BALL TEAM. No matter how small a village was, it had a ball team. Here is the Averill ball team of 1907. Pictured from left to right are the following: (front row) Sam Ebare and Bert Monroe; (center row) Raymond Seigel, Bernard Madison, Wilbert Campbell (manager), Charles Draves, and Emil Bensch; (back row) Ray Rider, Earnest Martzfelt, Fred Coates, and Otto Bensch.

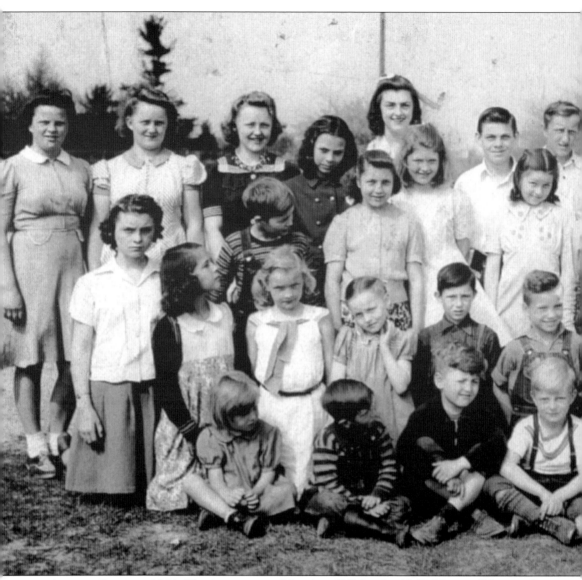

AVERILL SCHOOL, 1941. This is a picture of the Averill School c. 1940. Many still live in the area. From left to right are the following: (front row) unidentified girl and boy, Don Florey, and an unidentified boy; (second row) Mina Wilkinson, Cookie Florey, Beverly Decker, Roy Wilkinson, and Ed Gensel; (third row) Carolyn Sasse, unidentified boy, Beulah Wilkinson, Rosellen Florey, Lou Ann Finney, and Denny Finney; (back row) Maxine Waite, Mary Richardson, Esther Richardson, Colleen Strayer, Ardis Briggs, Frank Sasse, and Roy Draves.

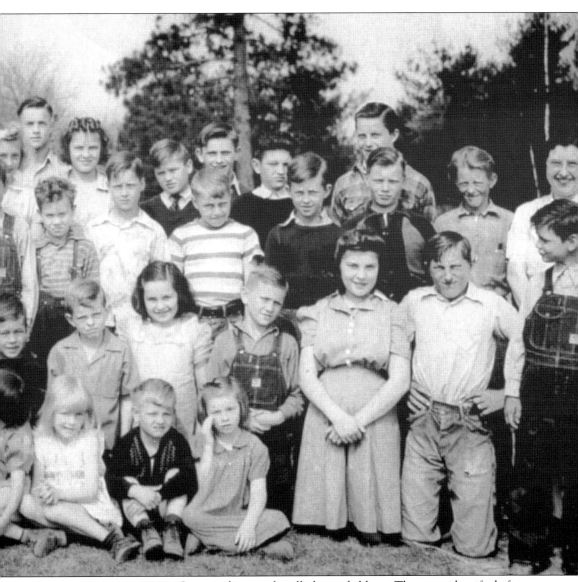

AVERILL SCHOOL, 1941. One teacher taught all these children. They are identified, from left to right, as follows: (front row) unidentified girl, unidentified girl, Claud Florey, and Carolyn Sasse; (second row) Dick Strayer, Lawrence Sasse, Jolene Decker, Dick Gensel, Lillian Stevenson, Fenton Draves, and Dallas Brown; (third row) Denny Finney, ? Decker, unidentified boy, Dick Moore, Gail Briggs, Bill Brown, Harry Press, and teacher Beryl Martin; (back row) Gloria Briggs, Harley Draves, Sally Florey, Max Waite, Charles Sasse, Bill Florey, and Paul Draves.

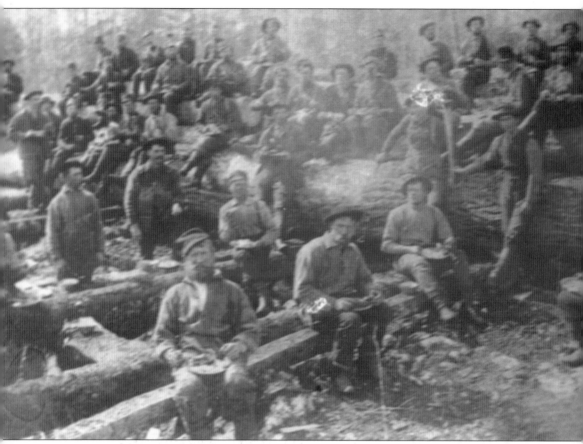

THE LUMBERJACK. The life of a lumberjack was a tough one; isolated in dense forests for long periods of time, sleeping in log bunks with straw ticks for mattresses, lumberjacks did hard and dangerous work. The slip of an ax meant that a man could bleed to death before help arrived. In the beginning, timber was cut in the winter because snow and ice made transportation easy: the cut timber was hauled to the water's edge to wait for the spring thaw. But when the big wheels were invented, timber could be cut year round. This invention, along with the narrow gauge railroad, was responsible for shortening the lumber boom originally forecast by the timber barons. The men who became lumberjacks were a special breed and when the timber boom ended, they found their way back to civilization piecemeal, but in their hearts they yearned for the old days for the rest of their lives. (Photo courtesy of Nancy Lackie, Sanford Museum.)

SANFORD

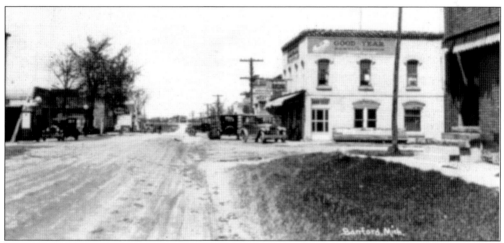

A man named George Butts arrived in the Sanford area in 1863, followed by Charles Sanford in 1864. For a short while, the Sanford area was called Buttonville or Button's Hole. But Charles Sanford platted the area and was given the privilege of having the new village named in his honor. In 1871, mail was addressed to Sanfordville but soon shortened to Sanford. A Mr. J. Hamilton was the postmaster. The Flint & Pere Marquette railroad reached Sanford by 1871, making the town accessible by both river and rail traffic. This meant that the hotel business thrived. By 1875, Sanford had a thriving shingle mill and 140 people resided there. The era from 1891 to 1905 was a period of tremendous prosperity for the little town of Sanford. By 1889, a stagecoach made a trip three times a week to Edenville; the round trip cost 75¢. Mail arrived and left Sanford daily. But as with all of the small towns that had depended on the lumber boom, Sanford found much of its population leaving for greener pastures—except for a few dedicated people who liked living in Sanford. Children and grandchildren of early Sanford settlers can still be recognized by names like Thornton, Bowen, Cole, Francis, Peck, Utter, Howe, Irish, Moe, Rogers, Haskell, Bowland, Bliss, Blakeley, Geiling, King, McMullen, McNett, Bacon, and Rogers.

As far as records go, apparently the first white person to spend time in the Sanford, Michigan, area was Douglas Houghton. In 1838, Douglas Houghton, State Geologist, drilled the wells that became known as the Tittabawassee Salt Wells. Hopes that the new State of Michigan would pursue the project failed when the depression in 1839 cut the project short.

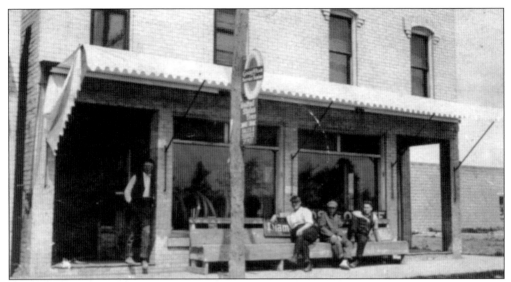

BENCH WARMERS. Allen Cole remembers that Frank Allswede put a bench outside his general store "for the guys to sit on." Henry Ford made it a habit to stop at Frank Allswede's general store and visit when he was on his way from Detroit to his experimental farm in Clare, Michigan. The farm was where Ford tractors were engineered and tested before being put on the market. Jim Francis is standing in the doorway. (Photo courtesy of Nancy Lackie, Sanford Museum.)

METHODIST EPISCOPAL CHURCH. After the flood of 1912, the Methodist Episcopal Church was moved to the corner of Cedar and Lincoln Streets in Sanford. Some of the early church families included Utter, Hansen, Haskell, Tuttle, Verity, Bassett, Scarlett, Samsell, Allswede, Jeffers, Cole, McNett, Knoop, Walker, Stevens, Snyder, Bye, Reed, Thorton, Lane, and Murphy. Allen Cole remembers attending Sunday school here with Mrs. Segerland his teacher. (Photo courtesy of Nancy Lackie, Sanford Museum.)

BURNS CAFÉ. George and Mabel Burns put up this building in 1924. The downstairs was a café and the upper story served as living quarters. The address was 353 West Saginaw. In 1935, the building was torn down and rebuilt into a one-story building. Today Pat Tracy's barber shop is located there. (Photo courtesy of Nancy Lackie, Sanford Museum.)

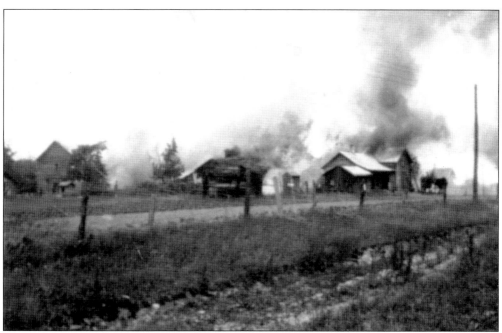

FIRE ALARM! There were no fire trucks or firemen when this picture of the Jim Francis hotel and livery barn burning was taken in July 1927. The story goes that one of the Brownlee fellows climbed on a rooftop and directed the men who were trying to control the fire with buckets of water. "Hey! Over there!" "Got another one over here!" (Photo courtesy of Nancy Lackie, Sanford Museum.)

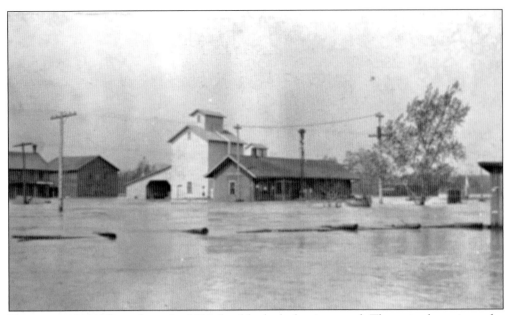

FLOOD OF 1912. This is how the 1912 flood looked after it crested. The train depot is on the right, Allswede's Elevator is in the middle, and Jim Francis' hotel and livery stable are on the left. Later, Jim Francis hired men to drive the teams to help with the construction of the new Sanford Dam and building new roads in the surrounding area. (Photo courtesy of Nancy Lackie, Sanford Museum.)

BUDGE DRUG STORE. Walter Budge moved to Sanford from Detroit and opened a pharmacy. He operated the pharmacy from about 1934 to 1944. He also sold candy and kept chickens in the back room. One day, Allen Cole went in there and he could hear chickens clucking. Walt said, "My chickens are cold. I put them in the back room." It didn't hurt his dispensing of medicine to the ill and ailing in Sanford. (Photo courtesy of Nancy Lackie, Sanford Museum.)

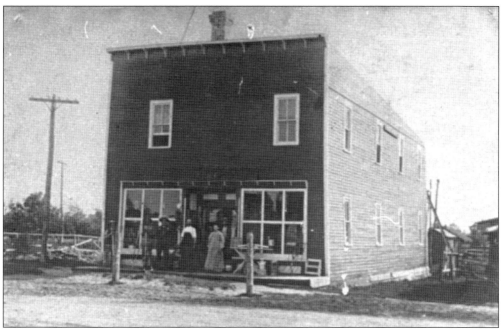

HASKELL HARDWARE. John Haskell and his father, Henry, owned and operated the Sanford Hardware from about 1904 to 1917. Living in the small town of Sanford, the Haskell family adapted to their new surroundings quickly. John's daughter Bessie married Nels Peterson on August 20, 1917. Around this time, John Haskell sold his hardware in Sanford and rented a building in Midland, moving his hardware stock there. The Chemical Bank is on that site today. (Photo courtesy of Nancy Lackie, Sanford Museum.)

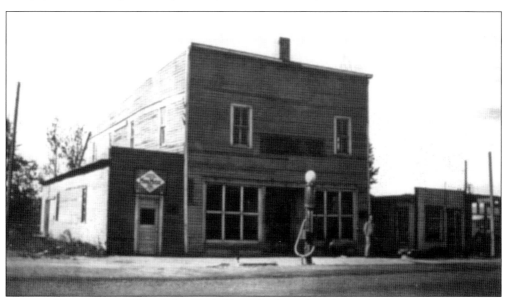

ROGERS HARDWARE. When John Haskell was looking for a buyer for his hardware store, he found one in Walter Rogers. Note the addition of a gas pump in front of the store. He also sold coal for heating stoves. A.J. Rogers took over the hardware store after his dad, Walter, died. (Photo courtesy of Nancy Lackie, Sanford Museum.)

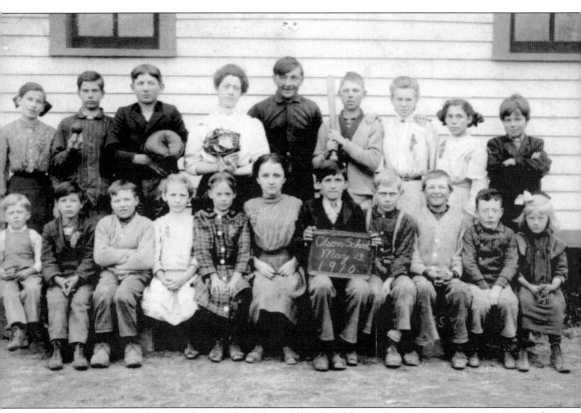

OLSON SCHOOL. This is a photo of the Olson School children taken on May 13, 1910. Pictured from left to right are as follows: (front row) Howard Miller, Lester Alexander, George Smith, Nettie Larsen, Grace Miller, Carrie Swarthout, Joe Krotzer, Frank Smith, Glen Plummer, and Eva Larsen; (back row) Bernice Alexander, Harry Peek, Otto Tohm, Anna Mason (teacher), George Swarthout, Frank Hoon, Olga Friedunk, Dora Krotzer, and Arnold Gregory. The Olson School was just one of the many rural schools in the Sanford area at the turn of the century. (Photo courtesy of Nancy Lackie, Sanford Museum.)

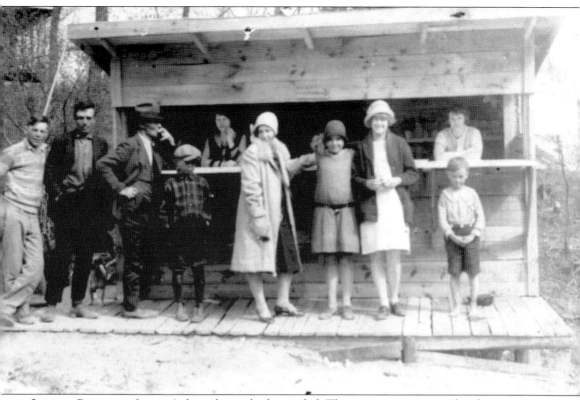

LUNCH COUNTER. It wasn't fancy but nobody minded. This was a new summer lunch counter at Francis Grove. Waiting their turn are the following people from left to right: Howard Peters, Glenn Hubbard, James Francis, Ed Weakman, Ellen Segerland, Helen Hubbard, Elva Weakman, and LeRoy Hubbard. Behind the counter are Lola and Pearl McNett. This picture was originally identified as the Snow Flake, but Allen Cole remembers the Snow Flake "as a hot spot between the two dance halls." One of the dance halls was at Francis Grove on Sanford Lake, and the other was the Sheepshed off Center Street near M-30. The Snow Flake restaurant sat on Center Street where an apartment house is now. (Photo courtesy of Nancy Lackie, Sanford Museum.)

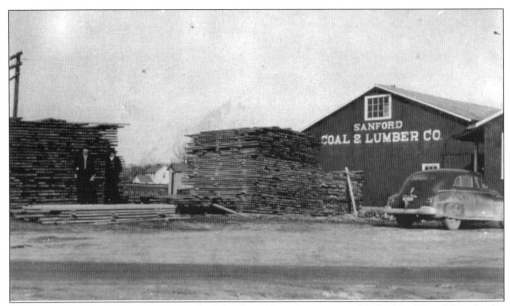

SANFORD COAL AND LUMBER. Sanford Coal and Lumber was established by Tom Maticka Sr. in Sanford, Michigan. Tom came to America from Austria as a young man. When he cashed his first paycheck, the bank teller gave him $5 instead of $50. Discovering the mistake, he turned back to the teller but she waved him off, saying, "We can't make any adjustments after you leave the window." Tom said, "That was my first paycheck in America." (Photo courtesy of Nancy Lackie, Sanford Museum.)

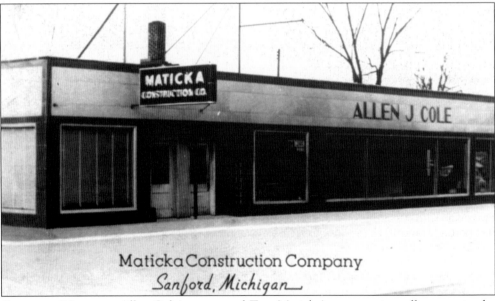

COLE AND MATICKA. Allen Cole's garage and Tom Maticka's construction office were in the same building. A third business went in between them shortly after this picture was taken: Sanford Plumbing & Heating. These were the post-war years and the construction business was booming. Down payments were $300 to $500 and monthly payments were as low as $25. (Photo courtesy of Nancy Lackie, Sanford Museum.)

COLEMAN

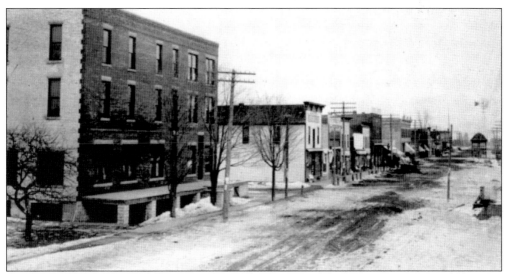

COLEMAN MAIN STREET 1908. (Photo courtesy of Midland Historical Society.)

In 1867, the Flint & Pere Marquette Railroad reached Midland. In 1868, it reached Averill, and in 1870, the tracks were laid through Coleman, the only village in Warren Township. In 1869, Ira Adams arrived in Warren Township. Three days after Adams' arrival, Samuel Hubbell came by ox cart with his family to establish residence in Warren Township. Mr. Adams brought the first portable sawmill to the area and Mr. Hubbell built the first shingle mill.

The first people to come to Coleman experienced the barest of living conditions. The Samuel Hubble family lived in a tent for six weeks until a log cabin could be built. Abraham Fraser's family stayed in a makeshift covering of hemlock boards until their home could be built. When it rained, they held an umbrella over themselves to keep dry.

Some of the names from Coleman's early days are Pierce, Hubbell, Clark, Simons, Miller, Post, Fraser, Chatterton, Embury, Cade, Howe, Carty, Duel, Doherty, Hyde, Niggeman, Bowland, See, Curtice, Watson, Yager, Husted, Burke, Pontious, Bolenbaugh, Carter, McKay, and High. Many of the children, grandchildren, and great-grandchildren of these families still live in the town their ancestors settled.

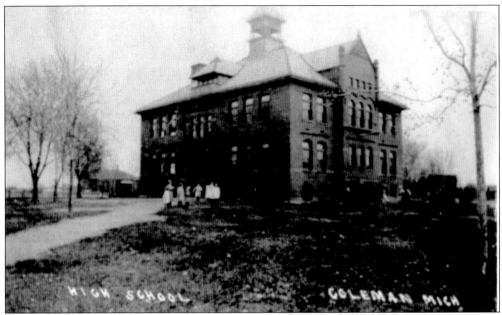

COLEMAN SCHOOL. In 1894, Coleman's first school building burned, and in 1895, this brick building was erected on the same site, at the corner of Railway and First Streets. It accommodated Kindergarten through the tenth grade. By 1899, grades eleven and twelve had been added. In 1922, this building was destroyed by fire.

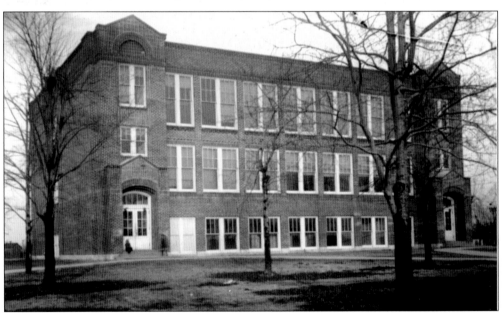

NEW COLEMAN SCHOOL. The new school was built in 1923. Later, a gym, a shop, and a bus garage were built. By 1949, annexation came to the Coleman schools, which required more classroom space. As a result a new elementary school was built, followed by a new high school. The present Coleman High School is almost directly across from the spot where Coleman's first school stood, on land donated by Samuel Hubbell in 1871. (Photo courtesy of Midland Historical Society, Gary Skory.)

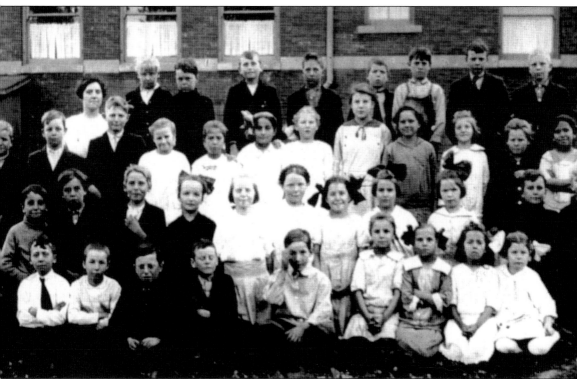

FOURTH GRADE, 1916. This is the fourth grade at Coleman in 1916. Pictured from left to right are as follows: (front row) Levi Klingler, Vernell Berk, Carl Slocum, Edward Haines, Harold Graham, Lillian LeMay, Florence Dolph, Lucille Monroe, and Althea Hall; (second row) Eugene Allen, Glen Yager, unidentified, Aleta Yager, Muriel McFarland, Helen Burke, Catherine Black, Josephine Simons, Ruth Hyde, Freeman Seaton, and Clifford Yager; (third row) Lloyd Pontious, George Pontious, Bill Jones, Gladys Roebuck, Ethel Rose, unidentified, Hazel Gilman, unidentified, Gladys Miley, Ople Grimm, Martha ?, and Nellie DeJongh; (back row) Miss Vera Welch, Aaron Cline, Eugene Bowland, Theodore Jones, Cecil Dagon, Basil Gothrup, Martin ?, Everett Haines, and Walter Baker.

COLEMAN TOWN HALL. When Mrs. E.W. Simons wrote her memoirs of the history of the Methodist Church in Coleman, Michigan, she said, "The first Methodist church services were held in the town hall by Reverend A. Cram, who, like the evangelists, walked the long miles from Edenville one Sunday a month." The first Methodist Society, organized in 1879, held their meetings in this Village Hall in 1880. This is how the Village Hall looked in 1940.

ORIGINAL METHODIST CHURCH. The original Methodist Church was completed in 1884 on a site given by the T.B. Simons family. (T.B. Simons was an early settler and businessman in Coleman.) The first minister in the little country church was Reverend Younglove. This was a wooden structure which burned to the ground in 1901. The present stone building was erected in 1902. (Sketch by Delores Groves.)

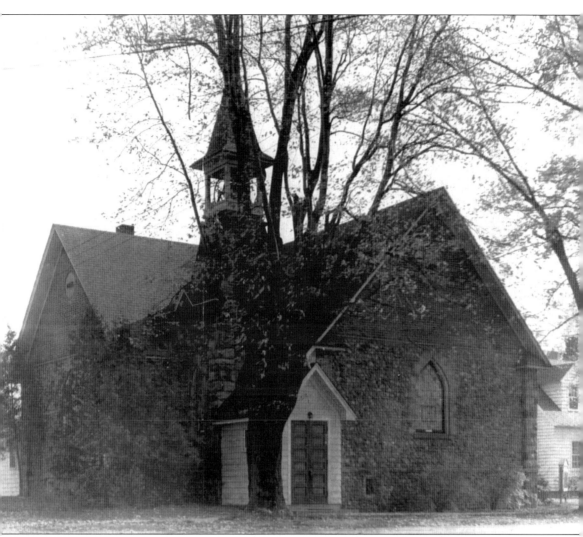

METHODIST CHURCH IN COLEMAN. Rebuilding of the Methodist Church began immediately following the fire of 1901. Everyone gave their labor, time, and treasure, and in 1902, the new church built of fieldstone was completed. Stoves and oil lamps supplied heating and lighting for the new little church. Water was carried by the pail from a pump across the street. In 1949, during the ministry of Reverend Fern Wheeler, the congregation voted to remodel the sanctuary. This project, including a new roof, cost $2,270 (a substantial sum for 1949). The building committee was reactivated in 1971 to consider further remodeling, and after investigation, it was decided to completely restructure the exterior and interior of the present building. On Palm Sunday 1973, the congregation worshiped in the transformed sanctuary. As Mrs. E.W. Simons wrote in her memoirs, "The church was remodeled almost beyond recognition, but the old walls and foundation still stand, altered on the surface it is true, but a solid tie to the past."

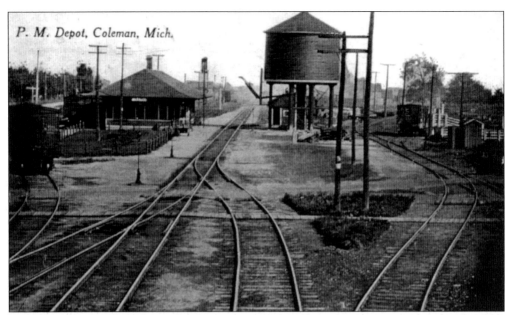

P. M. Depot, Coleman, Mich.

COLEMAN DEPOT. The Flint & Pere Marquette Railroad was descriptive of the location of the proposed line, which went from Flint, Michigan, to Pere Marquette, Michigan. The latter city subsequently changed its name to Ludington. The original station in Coleman was built in 1870 and was destroyed by fire in 1902, but replaced by a new station the same year. Passenger service was discontinued November 30, 1949, and freight service was discontinued in the summer of 1963.

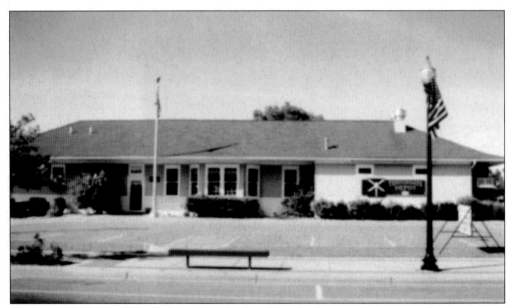

YESTERDAY'S DEPOT. Wanda Lewis bought the old train depot in Coleman and this is how it looks today as Yesterday's Depot. In the dining room of the new restaurant, they have installed a miniature electric train running on a track near the ceiling. Today the old railroad tracks have been replaced by the Rail Trail, which has become increasingly popular with walkers, bikers, and skaters.

NORTH BRADLEY. Originally called Buttonville, North Bradley was a small town between Sanford and Coleman. Originally this building was a hotel owned in turn by Edwin Powers and then Charles Vance. The small wing at the left housed a saloon. Later, during the ownership of Joseph Morrison, it became this general store and the saloon became a post office.

BUTTONVILLE INN. In the early 1950s, Candy Vanderpool babysat in this house. Candy remembers loving the old house and the whistle of the train as it went by each day. Her dream of opening a bed and breakfast became a reality when she and her husband Ron purchased the old house. On May 14, 2001, the Buttonville Inn Bed and Breakfast officially opened next to the Rail Trail.

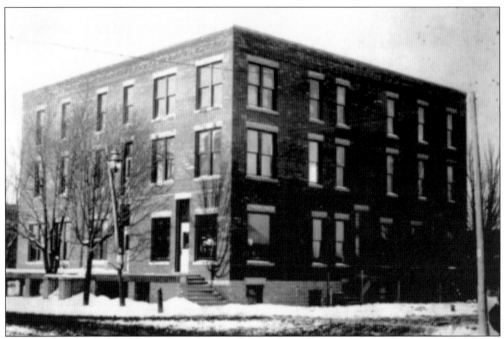

HECOX HOTEL. Built in 1903 by Henry Hecox, the Hecox Hotel was on the corner of Railway and Fifth Streets in Coleman. (Photo courtesy of Midland Historical Society, Gary Skory.)

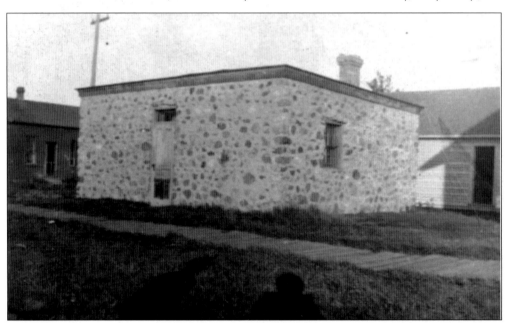

COLEMAN JAIL. For many years, Midland County had no county jail. Prisoners were housed in the Bay County jail. In 1898, Coleman decided that transporting and paying for the keep of law-breakers while awaiting trial was too expensive, so Levi Yager, a stone mason, was hired to erect a small stone jail just north of the town hall at the corner of Washington and Sixth Streets. All local law violators awaited trial there. In 1948, the jail was torn down and the jail site became a playground. (Photo courtesy of Midland Historical Society, Gary Skory.)

Two

THE RIVER CORRIDOR
HOPE AND EDENVILLE

When Harvey Parke platted Midland County in 1831, the village to the north of Midland, near the Tittabawassee and Tobacco rivers, was given the name "Sixteen" in recognition of its geographical location in Midland County. It was platted as Town 16 North Range 1 West. Because this was a little cumbersome to rattle off, the name was soon shortened to Sixteen. It remained Sixteen until 1869, when the United States Post Office advised Henry Church, the local postmaster at Sixteen, that an official name had to be given the little post office. Although the area was known as Sixteen throughout Michigan, for some reason this name didn't satisfy the United States Post Office.

Taking a walk that evening, Henry Church came to the spot where the Tittabawassee and Tobacco rivers joined and in his state of mind, looking down at the rivers surrounded by tall pines, he thought of the Biblical Garden of Eden. Standing there, surrounded by the quiet rivers and the forest behind him, he decided that this would be his Eden on earth; and thus Edenville became a town. The next day, Henry Church wrote the U.S. postal officials that the town was to be called Edenville. (Photo courtesy of Galen Gransden.)

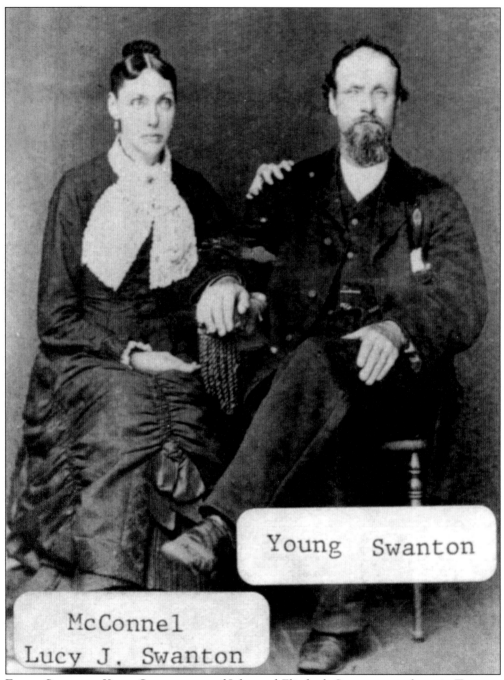

Young Swanton

McConnel
Lucy J. Swanton

EARLY SETTLERS. Young Swanton, son of John and Elizabeth Swanton, was born in Toronto, Canada, in 1836, which is where his father died in 1844. In 1849, his mother married Thomas Gransden, joining the Swanton and Gransden families. On April 11, 1859, Young Swanton married Lucy J. McConnell. In 1870, Young Swanton and his brother John came to Edenville. The original farm stood south of the old Edenville school on the west side of Water Road. Today the legacy of the Swanton family continues in Edenville with the Lafayette Swanton Memorial Center. (Photo courtesy of Galen Gransden.)

YOUNG SWANTON FARM. Young and Lucy (McConnell) Swanton spent their married life on this farm in Edenville. The story is told that when Lucy died, her father thought he should get her estate. He didn't. After that, he refused to walk on that side of the road because his son-in-law continued living in the house. (Photo courtesy of Galen Gransden.)

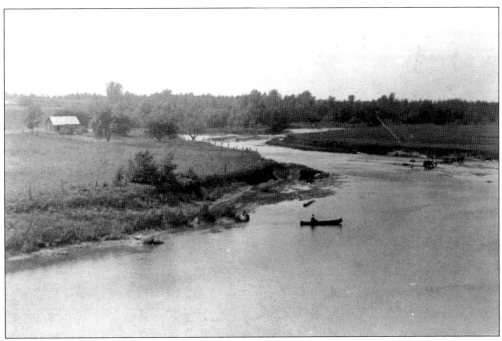

1915 PASTORAL SETTING. A solitary figure sits in a boat at the junction of the Tobacco and Tittabawassee rivers in Edenville in 1915. This was before Frank Wixom had established the Wolverine Power Company and began the project of building five dams in the area, which would change the future of Edenville forever. (Photo courtesy of Galen Gransden.)

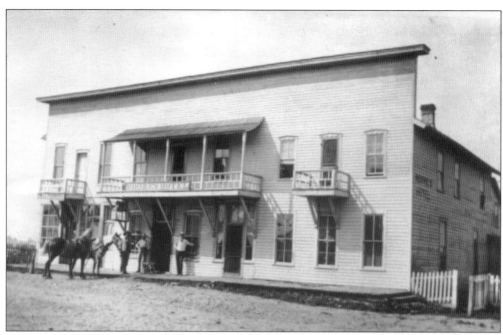

TOM MOORE'S HOTEL. Thomas Moore, born in 1839 in Canada, moved to Sixteen (Edenville) in 1866 and operated a hotel which burned down in 1874. He took the insurance money and bought the Franklin House in Saginaw, but six months later found himself bankrupt and in debt. He moved back to Edenville with his wife, Caroline Ladow, to farm and to rebuild his first hotel, which he ran until his death. (Photo courtesy of Nancy Lackie, Sanford Museum.)

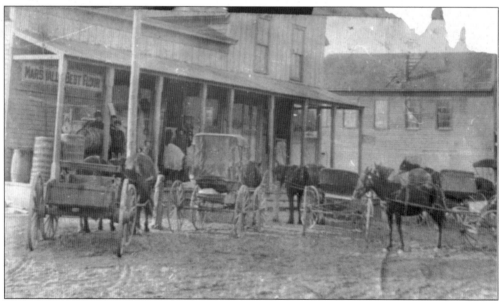

HARPER'S STORE 1906. Charles Harper was born in 1853 in Ohio and worked for the Wright & Ketchum Lumbering company at their headquarters camp in Hope as a young man. In 1888, he married Ida Swanton and opened a general store in Hope. In 1891, they moved to Edenville and established this general store there. (Photo courtesy of Nancy Lackie, Sanford Museum.)

HOME OF TOM AND CAROLINE MOORE. Tom Moore was born in 1839 in Canada. He went to Ann Arbor, Michigan, in 1862 and then moved to Saginaw where he met and married Caroline Ladow in 1864. In 1866, Tom and Caroline had their only child, a little girl, whom they named Georgianna. That's the year they moved to Edenville and Tom went into the hotel business. In 1872, his little girl died, and in 1874 his hotel burned down. Tom and Caroline moved to Saginaw briefly to operate another hotel, went bankrupt, and moved back to Edenville where they lived for the rest of their lives. Tom Moore was never the same man after the death of his little daughter. (Photo courtesy of Galen Gransden.)

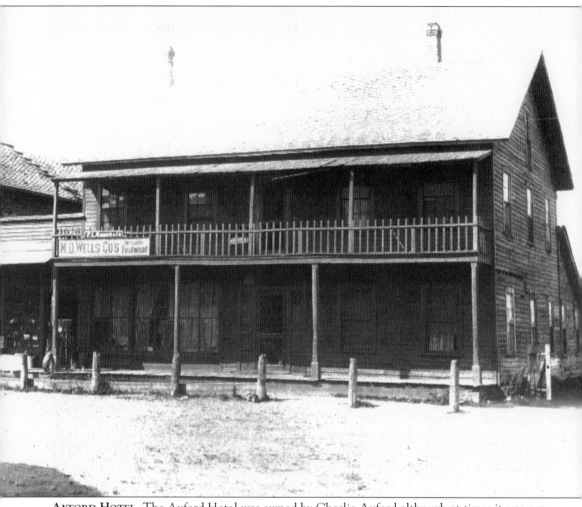

AXFORD HOTEL. The Axford Hotel was owned by Charlie Axford although at times it was run by others, including Tom Gransden and Luther G. Carter. When the old Axford Hotel was torn down, a wad of old clothing was found stuffed in the stairwell. This seemed to lend credence to the story that a man had been murdered at the Axford Hotel and his body thrown down a well by two prominent men of Edenville. Folklore dies hard. Charlie Axford, the hotel owner, was also Justice of the Peace and officiated at a short trial where Billy McCrary pleaded guilty and was fined $3.00 for striking a lumberjack. Everyone went back to the Red Keg Saloon in Averill where Charlie slapped the $3.00 down on the counter and said, "Set'em up, Billy, as long as the money holds out." (Photo courtesy of Galen Gransden.)

EDENVILLE FIRE TOWER. Before the days of modern technology, fire towers were necessary to alert people about forest fires. These fire towers were situated on the highest available ground in the forests and were manned by one person who radioed his report to one of the conservation district offices in their area. Once a common sight in Michigan, fire towers are only a part of our history today. (Photo courtesy of Galen Gransden.)

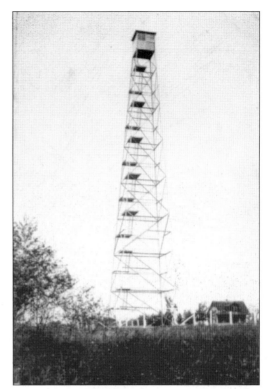

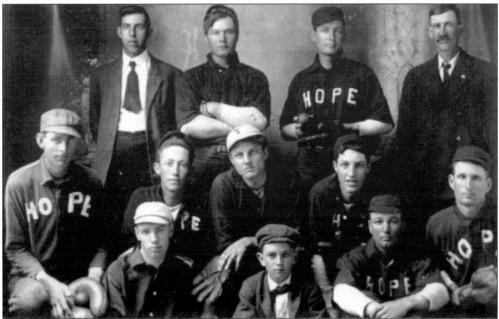

1910 HOPE BALL TEAM. The people who settled Hope were hard working and industrious, and though Hope was only a small village, they still had a great ball team. Pictured here from left to right are the following: (front row) Bob Joynt, Charley Mallory, Johnie Carey, Will Henry, Fred Swartz, Archie Henry, and bat boy Dennie LaRue; (back row) Marvin Earley, Charley Warner, Leon LaRue, and George Gregway. (Photo courtesy of Minnie Andrick Havens.)

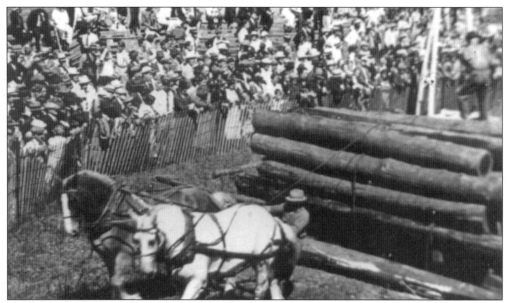

Log-Pulling Contest. Seeing how many logs a team of horses could pull was always one of the big attractions at Frank Wixom's Lumberjack Picnics. The spectators at the 1936 picnic watched in disbelief as a load of logs buckled under Fred Brasseau, the top loader on a pile of 35 logs, and caused him to leap for his life from a height of 15 feet to avoid being crushed by the falling logs. (Photo courtesy of Nancy Lackie.)

Miss Electricity. On August 16, 1932, Frank Wixom held the first of his Lumberjack Picnics on the banks of the Tittabawassee River in Edenville. A pageant was written for the occasion, and young women chosen from the area participated. Bertha Gransden Johnson was barely 14 years old at the time and was chosen to be Miss Electricity. (Photo courtesy of Bertha Gransden Johnson.)

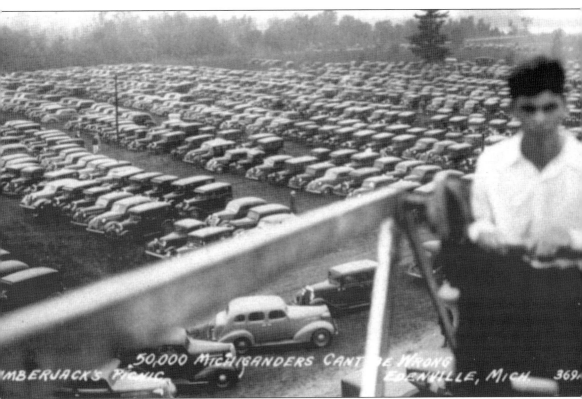

50,000 MICHIGANDERS CAN'T BE WRONG! Lumberjack Picnics began in Edenville in 1932, and when you had 50,000 people showing up for the event, parking became a major problem. This photo, taken from the top of the ferris wheel, shows cars parked on part of the 75 acres set aside for the occasion. Where did 50,000 visitors sleep? Some slept under their cars. The Ladies Aids from Hope and Edenville prepared prodigious quantities of food to serve in the two cafeterias. Meals were 50¢. On August 8, 1937, a lumberman's monument was set in the park. By 1939, the war was too close and travel too restricted to keep up the lavish celebrations, and the tradition of Lumberjack Picnics slowly came to a close. The year 1941 saw the end of the picnics. (Photo courtesy of Galen Gransden.)

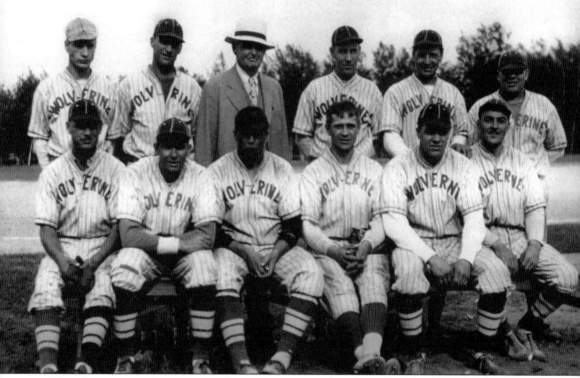

WOLVERINE BALL TEAM. Frank Wixom, the man responsible for the Sanford and Wixom lakes, started this baseball team, which traveled as far away as Toledo, Ohio. Considered semi-pro, they played teams from around the area. Although the front row is unidentified except for Ken Smith and Lou Finney, players in the back row are as follows: Clinton Rogers, Chris Walker, Frank Wixom, Ty Allswede, Lawrence Davids, and Dick Allswede. (Photo courtesy of Galen Gransden.)

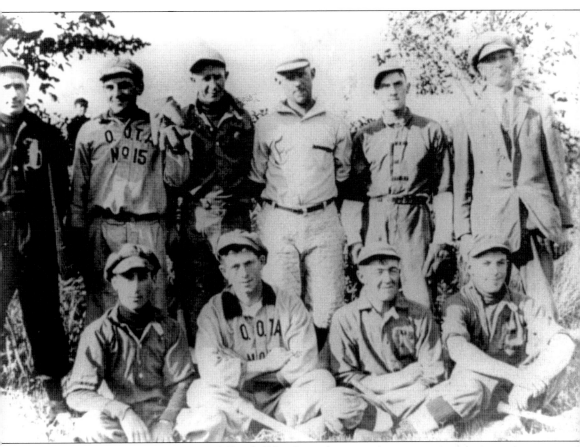

EDENVILLE BASEBALL TEAM 1915. Baseball has been the nation's pasttime since its inception, and Edenville was no exception. Here is Edenville's baseball team of 1915. Pictured from left to right are the following: (front row) Miles Jackson, Jack Bar, Estey Mitchell, and Pat Murphy; (back row) Lloyd Harper, Jed Murphy, Jim Wall, John Boman, Fred Woods, and George Card. (Photo courtesy of Galen Gransden.)

HOPE HIGH SCHOOL. This is the High School in Hope, Michigan, as it appeared c. 1911, according to the printing on the postcard. The rural schools that dotted the areas at the beginning of the 20th century often enrolled everyone from Kindergarten up to the tenth grade. (Photo courtesy of Minnie Andrick Havens.)

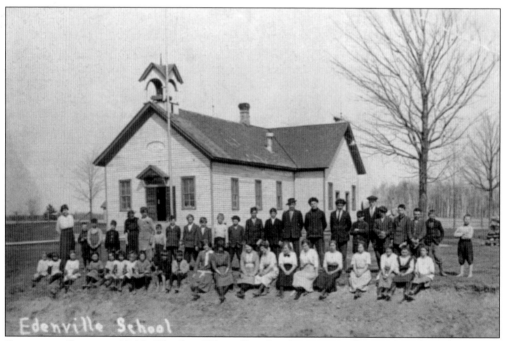

EDENVILLE SCHOOL, 1915. The first Edenville school was erected in 1861, when there were 14 pupils. By 1896, the school district's enrollment had grown to 140 pupils, necessitating new additions over the years. School was also held in two log houses in the Edenville area, in addition to this framed building. (Photo courtesy of Galen Gransden.)

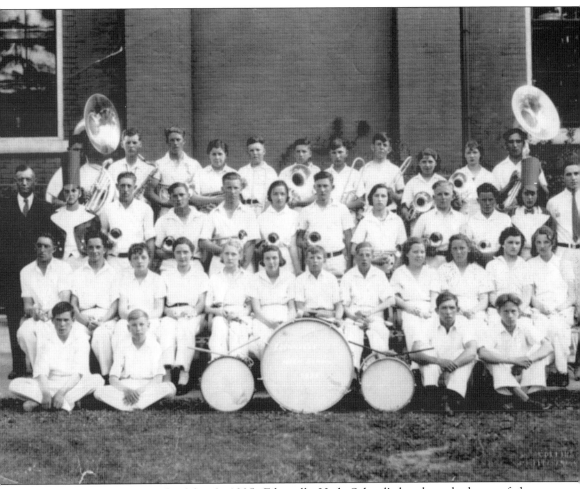

HIGH SCHOOL BAND. On May 9, 1935, Edenville High School's band reached one of the biggest moments of their lives when they participated at the Midland County Fair. On October 10, 1935, the first school bus in the county was purchased for the Edenville schools. This photo shows the 1935 band. Pictured from left to right are the following: (front row) Pat Gransden, George Sterling, Harlan Roebuck, and Elmer Carrigan; (second row) (William/Harold) Richardson, John Bacon, Eleanor Miller, Evelyn Eddy, Muriel Henry, Alpha Blodgett, Jack Leuenberger, James Bacon, Ruth Finch, Edna Seymour, Nellie Witer (?), and Frances Childs; (third row) James Secor Sr. (Instructor), Isabel Wisner, Albert Bacon, Lawrence Seymour, Robert Ritter, Evelyn Levandoski, James Secor Jr., Irene Wells, Gwen Wisner, Claude Shepherd, Mildred Wells, and Keith Reed (band leader); (back row) Herbert Bates, Everett Richardson, Lloyd Crosby, Ruth Tremain, Gerald Huber, Calvin Carstens, Willis Wells, Harold Pease, Annie Rumelfanger, Cleo Lidster, and Harold Eddy. (Photo courtesy of Galen Gransden.)

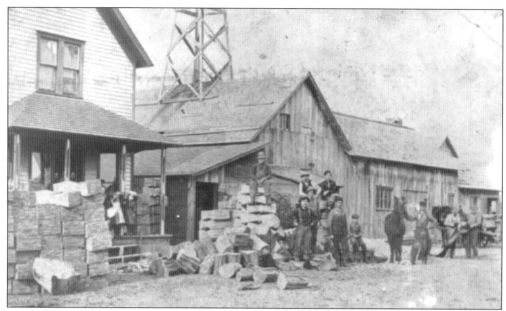

Carey Blacksmithing Outfit. One of the most famous names in the Hope area would have to be that of the Carey family and their blacksmith shop. This old photo on the back reads: "Carey's Carriage and Blacksmith Shop in Hope". (Photo courtesy of Nancy Lackie, Sanford Museum.)

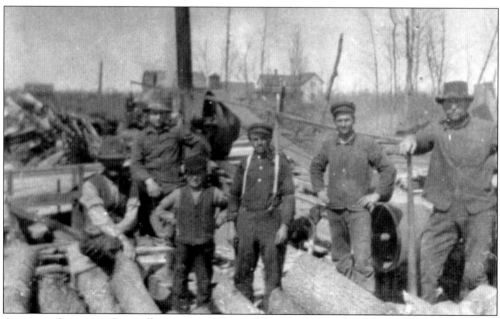

Andrick Sawmill. Sawmills were operating in Hope just as in the other villages surrounding them, although by the beginning of the 20th century, the large trees had already been logged off. Here are men at the Andrick Sawmill taking a break to have their picture taken. Pictured from left to right are the following: Ross Gotham, unidentified, Wesley Andrick, John Cline, Paul Cline, and John Andrick, owner of the sawmill. In the background is the Andrick homestead in Hope, Michigan. (Photo courtesy of Minnie Andrick Havens.)

LYLE GRANSDEN. Lyle Gransden was born in the old Axford Hotel in Edenville on October 1, 1899. He married Flora Swanton on June 18, 1919. Their first son Alden was born in 1920, followed by Lavon in 1930, and Galen in 1935. Galen and Lavon were born in the log house that had been built by their great uncle, John Gransden, upon his return from the Civil War in 1865. A skilled auto mechanic, on February 27, 1934, Lyle received a patent for the Convertible Car Seat Hinge. An ad at that time read, "This invention without a doubt will revolutionize the seating facilities of the automobile." Because this was the Depression era, the hinge was difficult to market and he finally sold his patent to the Saginaw Stamping and Tool Company for $500. Lyle died in 1974 and was given one of the largest funerals ever seen in Midland County. (Photo courtesy of Galen Gransden.)

JIM VANDERBUSH AND GALEN GRANSDEN. Pictured here are Jim Vanderbush and Galen Gransden in the Edenville Village Park, which came about as a result of a lot of hard work. The Carrigans, Vanderbushes, Fishers, Thurstons, Bacons, and Gransdens all had boys who wanted to play ball, and while there was a Little League in Hope, Edenville didn't have one. Galen got the idea of converting a vacant lot near his home into a park. The Lafayette Swanton Trust Fund furnished some of the money. Lyle Gransden furnished the equipment and the fathers in the area furnished their labor, which was a labor of love. Galen's family line on his dad's side (the Gransdens) and his mom's side (the Swantons) were early settlers of Edenville, and Galen still lives there with his wife, Margaret. Their three sons, Gary, Keith, and Glen, carry on the Gransden name. Jim and Galen remain neighbors, and the park still sits between them.

Three

INDUSTRY IN
A SMALL TOWN

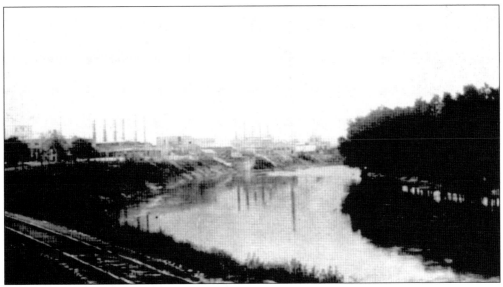

INDUSTRY POSTCARD OF DOW CHEMICAL COMPANY.

James Eastman set up a trading post at The Forks, which was the first industry in a small town. Before long a mineral well was discovered, and by 1880, the Village of Midland City was considered a resort town where people came for the mineral baths. The brine that lay under the village was responsible for several businesses before a young Herbert Dow discovered its full potential. Grist mills were flourishing as was a butter and tub works. Al Dickey had a bromine plant which employed 15 men. By 1897, The Dow Chemical Company was turning out "Dow Bleach" as the trade called it. A chicory plant operated here for a time. Furniture and hardware stores, barber shops, millinery shops, blacksmith shops, and funeral parlors all added to the business side of the Village of Midland City, which was rapidly outgrowing its original boundaries along the Tittabawassee River. Oil discovered in the 1930s brought about a brief oil boom. Dow Corning came into existence in the early 1940s. As the decades changed, so did the various industries in Midland. Some grew and expanded, others quietly went out of business or moved elsewhere. Here is a small glimpse of some of the industries that have kept our small town growing.

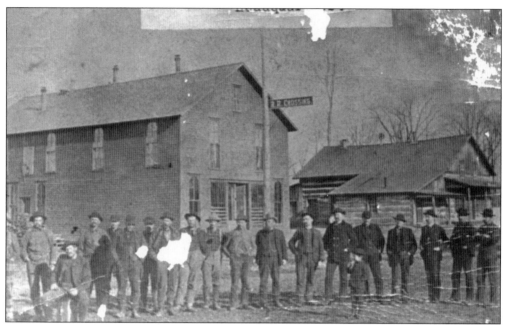

WRIGHT & KETCHUM HEADQUARTERS. From their dress, it's obvious that these are not lumberjacks but rather part of the timber baron contingencies that visited the lumber camps periodically to check up on their investments. This picture was taken at Wright & Ketchum's headquarters. Wright & Ketchum built one of the first narrow gauge railroads, and when it was finished it was almost 30 miles long, with 75 log cars, and 3 coal-burning engines. (Photo courtesy of Nancy Lackie, Sanford Museum.)

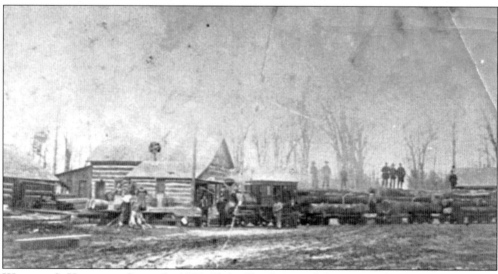

WRIGHT & KETCHUM CAMP. In 1881, Philip Ketchum and Ammi Wright went into business together creating the firm of Wright & Ketchum. They owned 10,000 acres of timber and began operations in the village they named Ketchumville, halfway between Averill and Hope. They had 8 camps and employed 500 men. Today all that remains of Ketchumville are some building foundations and old nails scattered in the grass. (Photo courtesy of Nancy Lackie, Sanford Museum.)

48

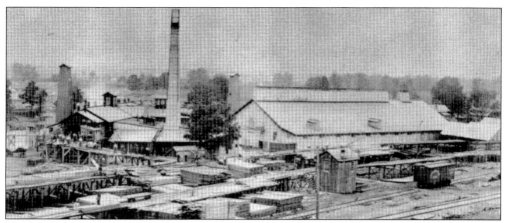

LARKIN AND PATRICK SAW MILL. In 1855, John Larkin founded a small mill, and in 1877 he went into partnership with William Patrick using the name Larkin and Patrick. By 1884, it was the Village of Midland City's largest industry. Larkin and Patrick dug the first salt well, sunk in the village to a depth of 1,300 feet. The resulting flow made it possible for Larkin and Patrick to produce 54,000 barrels of salt each year. The entire company covered about ten acres. The tall chimney in the picture was 85 feet high and was made with 120,000 bricks. The two brine wells in the picture are the wells from which Dr. H.H. Dow took samples of brine in 1890, before he settled here. On May 11, 1892, an explosion destroyed the mill, killing Charles Allen, Richard Steers, and Eugene Von Valkenburg. Eight others were injured. There were 90 employees at the time. The mill was partially rebuilt, but its days as the largest industry in the village were basically over.

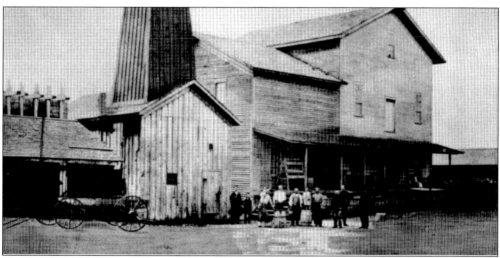

EVENS GRIST MILL. Probably one of the most famous pictures in Midland, this is a picture of the Evens Flour Mill where Dr. Herbert Henry Dow proved that he could extract bromine from brine electrolytically. This was done in 1890. Herbert Dow had come to Midland in 1888 to get some brine samples and returned to Ohio where he was a chemistry instructor at Cleveland's Huron Street Hospital College. In 1890, he returned to Michigan, visiting Alma, St. Louis, and Midland. He decided on Midland and on August 14, he leased the Evens Flour Mill on West Main Street to prove his theory. On January 2, 1891, Herbert Dow turned on the current to the cells in the Midland facility, and on January 4, iron bromide began to flow. This was the first ever electrolytically-produced bromine. The grist mill is long gone, and its site is a small park on West Main today.

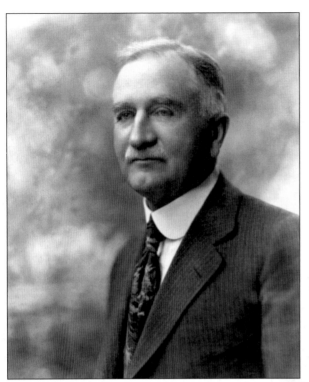

DR. HERBERT DOW IN 1910.
By 1910, sales for Dow's fledgling company had increased greatly with both bleach and bromides going great guns. The use of bleach as a disinfectant for water accounted for huge sales during typhoid and other epidemic scares in Cleveland, Ohio, and Chicago, Illinois. Carbon tetrachloride sales were good, and Dow's enthusiasm for horticulture was beginning to pay off with lime sulfur and lead arsenate sprays. (Photo courtesy of Post Street Archives.)

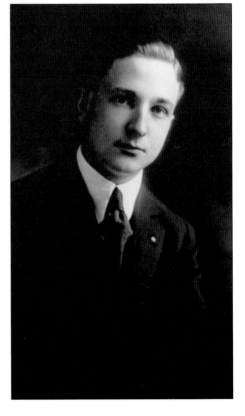

WILLARD DOW, 1915. The oldest son of Grace and Herbert Dow, Willard Dow was 18 years old in this picture. Becoming president of the company in 1930, he steered the company through the Depression and World War II. He died in a plane crash in 1949. Judge Henry Hart once said, "Though the odds are against it, sometimes the sons can become great men themselves and Willard Dow became a great man." It was the perfect epitaph for Willard Dow. (Picture courtesy of Post Street Archives.)

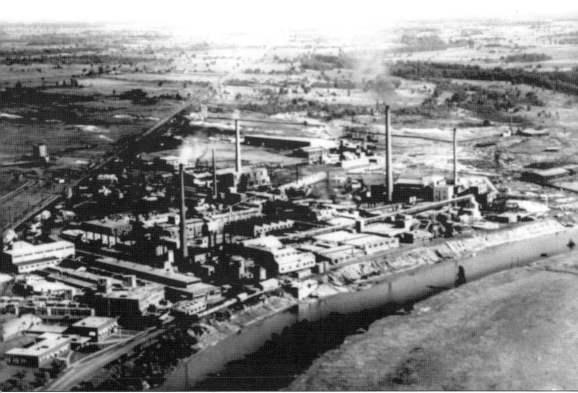

THE 1924 DOW CHEMICAL COMPANY. By 1924, the company had survived many obstacles. In 1903, there was a bleach war with England. By the end of 1903, Dow was selling bleach for 86¢ per hundredweight, a price the competition couldn't meet. The "Bromine War" began in 1905 and lasted for four years. The "Bromine War" ended in 1908 with prices bottoming out at 10 1/2¢ per pound. But sales of carbon tetrachloride and agricultural sprays exceeded all expectations. Then Dow made the decision to stop selling bleach—chlorine was too valuable to sell in the form of bleach. In 1915, the United States was at war with Germany, and Dow Chemical was in the unique position of being able to supply products that Germany had previously sold. In 1916, employment tripled. New products ignited the company's sales and the expansion of the auto industry largely affected the chemical companies because of the additives to gasoline. (Photo courtesy of Post Street Archives.)

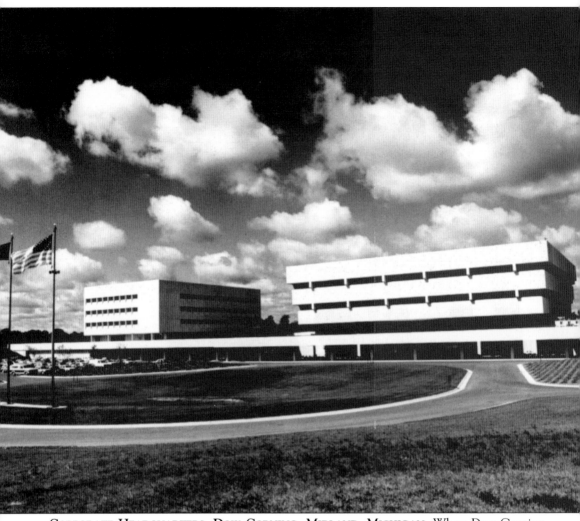

CORPORATE HEADQUARTERS, DOW CORNING, MIDLAND, MICHIGAN. When Dow Corning began in Midland in the 1940s, the switchboard, payroll, purchasing, and sales were all in one small red brick building. O.D. Blessing was head of Sales. Anita Sugnet and Ardis Briggs worked the switchboard taking phone calls. John Church was in charge of advertising, and he had his office in a quonset hut that was nicknamed the "sheepshed." There were a lot of quonset huts housing various departments. Some of the young women working were waiting for their husbands to come home from the service (World War II had ended). Dow Corning was considered so far out that the office staff, as well as the hourly workers, carried lunches, and if they wanted coffee they brought a thermos jug from home. But even then, everyone knew that Dow Corning was slated for big things. (Photo courtesy of *Midland Daily News*.)

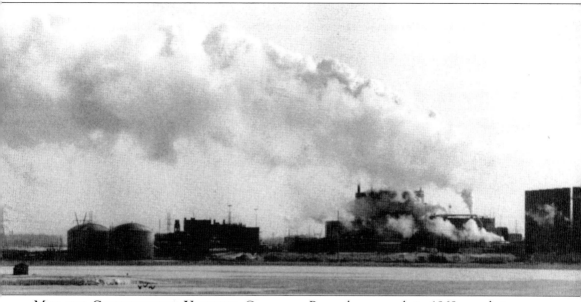

MIDLAND COGENERATION VENTURE. Consumers Power began work in 1968 on what was slated to be the largest nuclear industrial complex in the world, just one mile from Main Street in Midland, Michigan. The completion date was scheduled for 1972, but problems plagued the project, and by 1978, it still wasn't ready for operation. On July 16, 1984, the nuclear plant was shut down, and in 1987, the defunct nuclear plant was converted to a natural gas-fired cogeneration facility, which was completed in 1990. Today it provides steam and power to Dow Chemical, and electricity for Consumers Energy customers. (Photo courtesy of *Midland Daily News*.)

MIDLAND HOSPITAL. On April 8, 1941, Mrs. Grace A. Dow donated 40 acres on Orchard Drive for the new hospital. Its setting in the 40-acre woodlot of pine, elm, oak, and white birch trees brought a sense solitude and peace. Space for 47 beds was considered adequate. Although it started out small, the hospital was renamed MidMichigan Regional Medical Center and is now one of the largest industries in Midland. (Photo courtesy of MidMichigan Regional Center.)

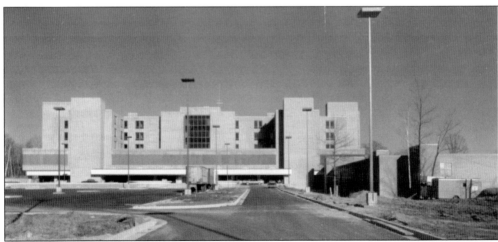

MIDMICHIGAN REGIONAL CENTER TODAY. The men who gathered on August 6, 1940, to discuss building a hospital for Midland never dreamed what that hospital would become in half a century. Spearheaded by Phil Rich, Wayne McCandless, and Morley Blackhurst, 20 men showed up to form the Midland Hospital Associaton. Phil Rich was elected president. On March 15, 1944, the new hospital opened for maternity patients, and in April it was officially opened. (Photo courtesy of MidMichigan Regional Center.)

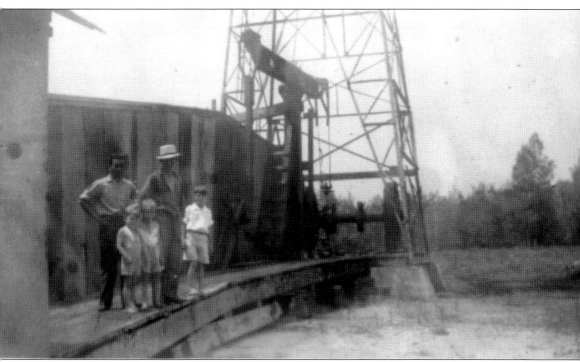

THE YOST OIL FIELD. By 1932, oil wells were being drilled in the Mt. Pleasant area, and by 1934, Porter Township had 55 active wells. In 1937, the Sun Oil Company had moved to Edenville and was ready to sink its first well. It was beat to the punch by Chapman Oil when oil was discovered in Section 27 of Edenville, just over the Gladwin County line. The well flowed 500 barrels in the first 24 hours. The Pure Oil Company operated the Yost Oil Fields and Dale Brandon remembers his dad getting a job there. This was during the depths of the Depression and jobs were hard to come by, but Clyde Brandon was following in his dad's and grandfather's footsteps in the oil business. Clyde Brandon took his wife and three sons with him to Michigan to work for Pure Oil. Pictured from left to right are a visitor from Ohio, Clyde Brandon, and his sons Dale, Keith, and Dean.

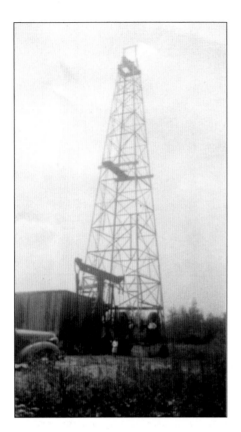

OIL WELL. The Yost Oil Field was drilled in an area of wooded sand ridges and swamps filled with mosquitoes, frogs, deer, raccoons, beaver, and rabbits. Men from Ohio, West Virginia, Texas, and Oklahoma came to Michigan to work in the oil fields. By 1937, the oil boom ended, but before it did, the Conservation Department had issued 200 well-drilling permits, and 33,651 barrels of oil had been taken from Midland County.

THE BRANDON FAMILY. Clyde Brandon took his family with him when he went to work in the Yost Oil Fields in Greendale Township, Midland County. In 1938, Clyde was transferred to the Temple Oil Field in western Clare County and life in the Yost Oil Field came to an end. In the picture are Florence Brandon and a visitor from Ohio, as well as Dean, Keith, and Dale Brandon.

Four

LEGACY

From the very beginning, the small town of Midland, Michigan, was blessed with men and women who wanted to give something to make their town a better place to live. Long before formal foundations were set up to dispense largesse, individuals gave of both their time and talents to enhance the quality of life around them. A point to remember is that many of the men who gave so much started out life in humble circumstances. Herbert Dow wanted to be an architect but when the family didn't have the money to send him to an architectural college, he enrolled at the Case School of Applied Science in Cleveland and became a chemist. Gilbert A. Currie Sr. was born to a farming family in what was called the Bluffs (now Mapleton) in Midland County and learned early on that he had to forge his own way

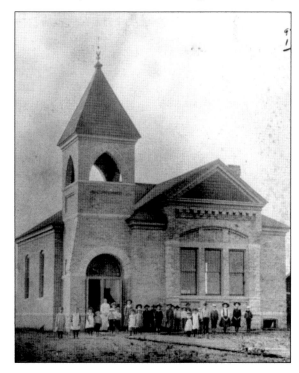

in life. Frank Wixom was born in a log cabin and tinkered with a half dozen businesses before settling down to his life's dream of harnessing the electric power in the Tittabawassee and Tobacco rivers. In an interview in 1993, Carl Gerstacker, one of those who gave generously to our town, said, "I really do these things because I'm selfish. I live here. I want this place to be the finest place in the world because I live here." Space limits us in mentioning all of the advantages that the small town of Midland, Michigan, has been blessed with since she became a county in 1850, but here are some of the highlights.

GRACE DOW TEACHING AT POST STREET SCHOOL. This photo shows the old Post Street School when Grace A. Ball Dow was the young teacher there. (Photo courtesy of Post Street Archives, c. 1880.)

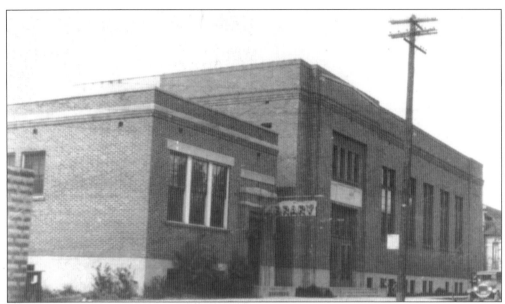

FIRST COMMUNITY CENTER. The first community center in Midland was located on Townsend Street and built in 1919 at a cost of $71,735. Myron Adams, a Baptist minister who grew up in Midland, was tapped by Herbert Henry Dow for advice. Adams proposed a community center with Guy Shipps from Chicago to be hired as the director. The center was an instant success.

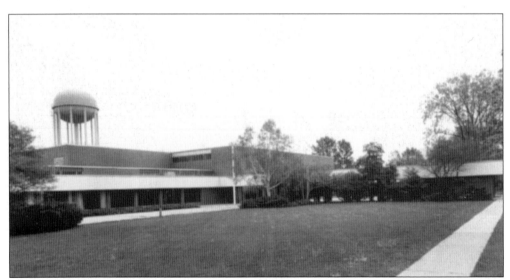

NEW COMMUNITY CENTER. Midland's new community center is located on George Street and increased from 11,000 square feet in the Townsend building to 90,000 in the new location. Opened on Tuesday, September 6, 1955, The Dow Chemical Company underwrote the entire $1.5 million cost. By 1981, close to a million people had used the center over the course of one year. (Photo courtesy of *Midland Daily News*.)

BUD TOWNSEND. A native Midlander (Townsend Street is named for his great-great grandfather), Bud began working at the Midland Community Center while in high school, and later during summer vacations from Central Michigan University. In 1955, he began his 40-year career at the center working with such people as Dave Russell and Roger Markell. (Photo courtesy of *Midland Daily News*, Glenn M. Roberts.)

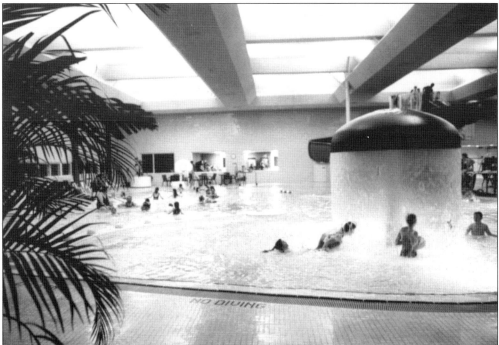

RAINDROP FOUNTAIN. This is the new swimming pool at the community center with the raindrop fountain—a far cry from swimming in the Tittabawassee River in 1923 under the auspices of the old community center. (Photo courtesy of *Midland Daily News*.)

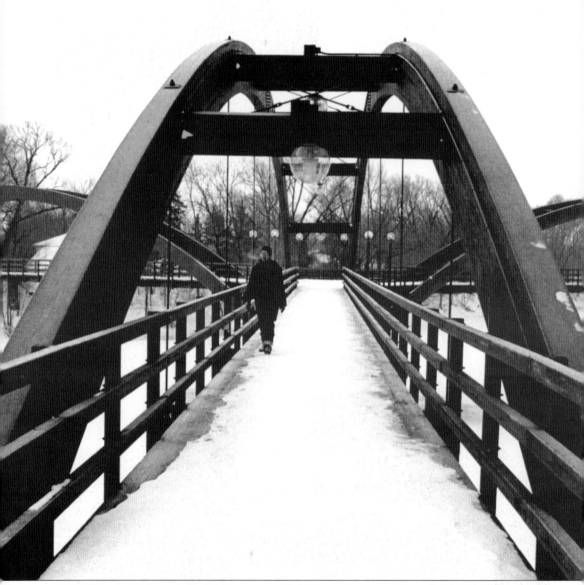

THE TRIDGE DEDICATION. This was an old-fashioned community get-together where Judge Henry Hart provided the opening remarks. Ribbon-cutting and the first trek across the Tridge began with fireworks at dusk. Entertainment was provided by John Walley, Bill and Jane Kuhlman, John Kelley, and coordinator Dave Bowen. The Midland Concert Band played. The Dirty Dozen men's vocal group sang. The Rotary Dixieland Band performed. The Midland Horn Club performed in a boat as it floated under the Tridge. The H.H. Dow High School band and the Central Intermediate band also provided entertainment. Selections from the Midland Music Society's upcoming *Man of La Mancha* were performed by Bob Burditt, Dale Schultz, Roger Putt, and Rocky Bailey. (Photo courtesy of *Midland Daily News*, Glenn M. Roberts.)

THE FAMILY. The William R. Dixon Memorial Fund commissioned this bronze sculpture done by Jim Hopfensperger, a local art teacher. Jim said, "Any artist I know would give their eye teeth to get a chance to do something like this." The sculpture is on a knoll in Chippewassee Park and shows a father, mother, son, and daughter holding hands.

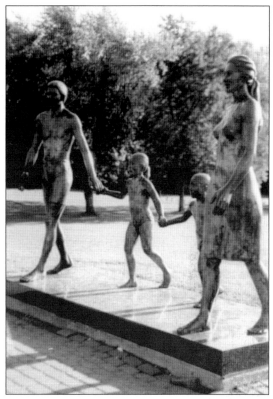

PADDLEBOATING AT THE TRIDGE. Most of us just thought this was a really wide spot in the river, but Carl and Esther Gerstacker were the visionaries to see the Tridge become a reality. Paddleboating at the Tridge, Esther Gerstacker and grandson Jon Joys (in the boat on the right) and Eleanor and Jim Pearce take a ride on the Tittabawassee. (Photo courtesy of *Midland Daily News*, Glenn M. Roberts.)

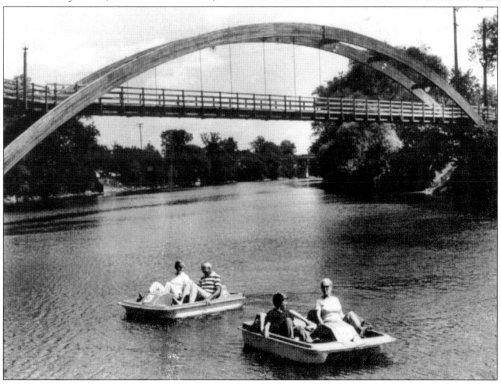

New Grace A. Dow Memorial Library Panorama. On April 12, 1950, Mrs. Grace Dow representing the Herbert H. and Grace A. Dow Foundation announced at the library board meeting that it would build a new library for Midland. On January 12, 1954, the Midland City Council adopted the resolution to name the new library the Grace A. Dow Memorial Library. The library officially opened on Monday, January 24, with an inventory of 16,940 books. (Photo courtesy of Grace A. Dow Memorial Library.)

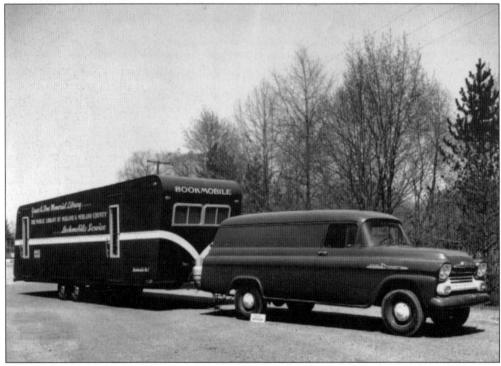

Bookmobile. Bookmobile service began in 1958, enabling children in the rural areas of Midland County to have access to library books. The Bookmobile continued through 1974. During my teaching career, one of my second-graders came back from the Bookmobile one day with a book called *The History of the Medicis.* I asked why and he said, "Because it was all I had time for!" (Photo courtesy of Grace A. Dow Memorial Library.)

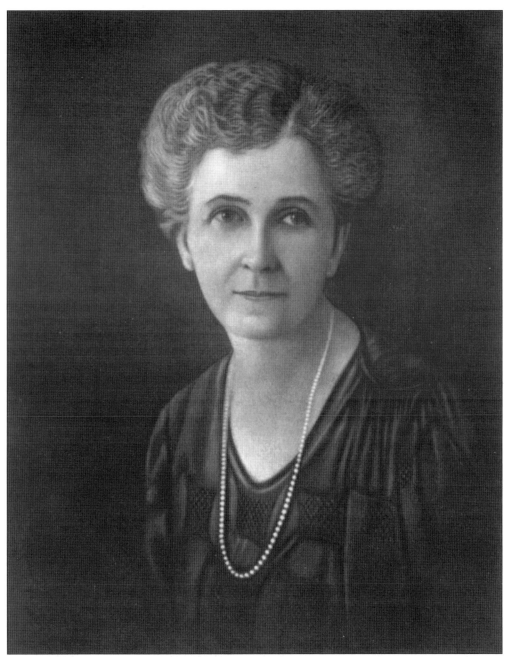

GRACE BALL DOW. Grace Anna Ball was born in 1869, the daughter of G. Willard and Amelia Ball. Like most young women of her day, she went to teaching school. She was teaching at Post Street School when she met a young chemist named Herbert Henry Dow. On November 16, 1892, she married him. She gave birth to seven children and endured the deaths of three of them. Osborne died at the age of three years in 1902. Helen died in 1918. Willard died in 1949. Personal tragedies were kept private, and to the community, she seemed to be a driving force in continuing the legacy that her husband had begun. Midland would be the poorer without her legacy and she remained a matriarch to the end. (Photo courtesy of Post Street Archives.)

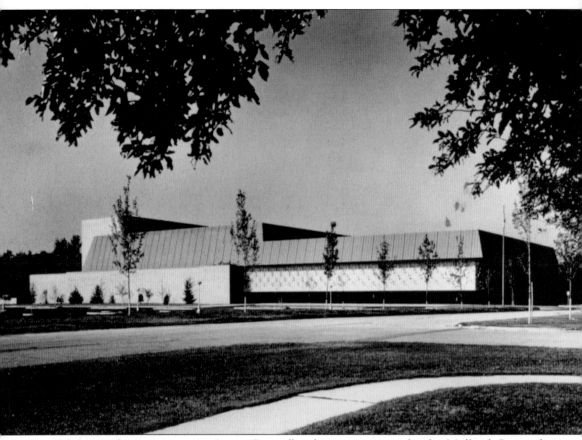

MIDLAND CENTER FOR THE ARTS. Groundbreaking ceremonies for the Midland Center for the Arts took place on Monday, July 8, 1968 at 7:30 p.m. at a site adjacent to the Grace A. Dow Memorial Library. Funds came from the Alden and Vaca B. Dow, the Herbert H. and Grace A. Dow Foundation, the Dow Foundation, and public donations. Six organizations found permanent homes there: the Midland Little Theatre Guild, Midland Music Society, Midland Art Association, Midland Symphony Society, Community Concerts Association, and Midland County Historical Society. Alden B. Dow was the designer and architect of the center. A dress rehearsal for the combined Midland Symphony-Midland Music Society Chorale concert was held the first weekend in December 1970, with the work crews and their families as special guests. Donald T. Jaeger conducted the concert. (Photo courtesy of *Midland Daily News.*)-

ALDEN DOW. This is Alden Dow on a horse at the family home on West Main Street. Born two years after the death of a brother, he grew up as a sheltered and introspective child. Even after his genius in the field of architecture was recognized world-wide, he remained a solitary figure, quiet and withdrawn to the point of diffidence. (Photo courtesy of Post Street Archives.)

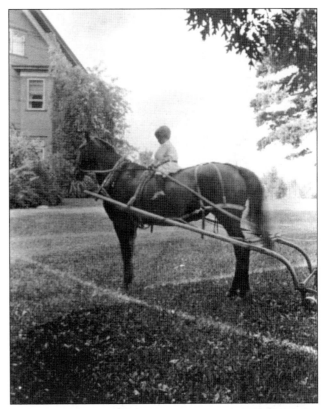

MIDLAND CENTER FOR THE ARTS. This is a view of the Midland Center for the Arts after it was landscaped. The Center has a 1500-seat auditorium, a 386-seat Little Theater, and numerous offices. This is just one of the advantages that a small town like Midland enjoys. (Photo courtesy of *Midland Daily News*.)

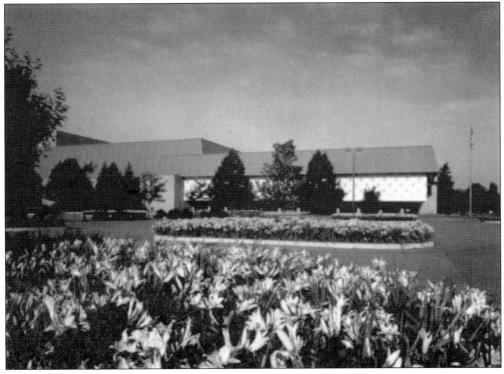

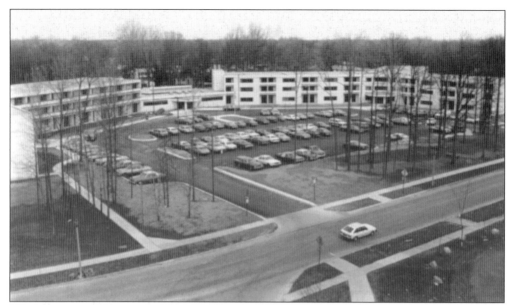

WASHINGTON WOODS. A 10-acre plot bounded by Cambridge, Washington, Dartmouth, and the back of Airfield Lane was chosen for the first senior citizens' building in Midland. It was Carl Gerstacker's dream to have a place where senior citizens could live comfortably and securely. To those living there, it continues to fulfill what he envisioned a quarter of a century ago. (Photo courtesy of *Midland Daily News*.)

WASHINGTON WOODS. During the grand opening Al Kiley, city housing director, gave a tour of the building to Carl and Esther Gerstacker. Showing each apartment, he made the comment, "There isn't a room in here that doesn't have a nice view." Special consideration was made to make the new move for many seniors as easy as possible. One lady wouldn't give up her piano and they managed to get it situated in her living room just where she wanted it. (Photo courtesy of *Midland Daily News*.)

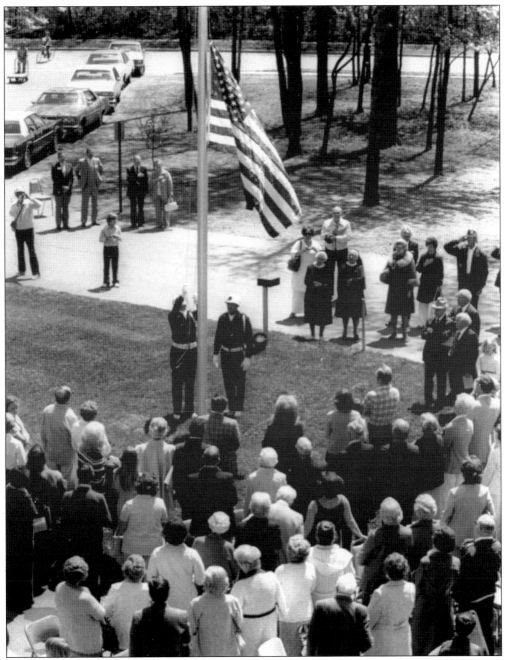

WASHINGTON WOODS. When the grand opening was held in 1977, 100 tenants were selected from the list of 275 persons who had applied. There were 80 one-bedroom apartments and ten two-bedroom apartments available. Bedrooms were 12-by-14 feet, the living and dining area was 12-by-16 feet, the kitchen was 8-by-8 feet, and the bathroom was 6-by-8 feet. The walls were ivory-colored, kitchens had garbage disposals and wooden cupboards, and each living room opened onto a small porch or balcony where residents could sit outside. Shag carpeting, smoke detectors, refrigerators, and electric ranges made the Washington Woods complex one of the best in the state of Michigan for senior citizens. (Photo courtesy of *Midland Daily News*.)

EMERSON PARK. Emerson Park was once 36 acres of wasteland known as Anderson's Flats, where the Emerson Drug Company of Boston, Massachusetts, operated a bromine mine. On August 26, 1926, Captain Isaac Emerson, owner of the Emerson Drug Company, gave the area to the City of Midland for a park at the suggestion of Gilbert A. Currie Sr. Little by little, Emerson Park emerged. Shuffleboard, swings, slides, and softball diamonds appeared. In the wintertime, Emerson Park had a large skating rink and was popular for sledding. In the summertime, it became popular for picnics and ballgames. (Photo courtesy of *Midland Daily News*.)

CURRIE STADIUM. Few people in Midland today realize that without Gilbert A. Currie Sr. there would be no Emerson park or Currie Stadium. In 1941, Mr. Currie offered to construct a softball stadium at Emerson Park. The new stadium was dedicated on May 23, 1942, when the Dow ACs played the Zollner Pistons of Fort Wayne, Indiana, to a standing-room-only crowd. This is a shot of Diamond 1 as it looked in 1958. (Photo courtesy of *Midland Daily News*.)

Five

OUR PURSUIT
OF LEISURE

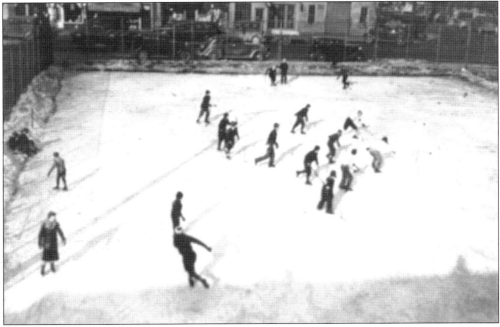

We pursue leisure in various ways. Some things we can do alone, like reading, listening to music, organizing scrapbooks, playing a musical instrument, walking, running, fishing, doing crossword puzzles, and daydreaming. Some things we do with others, like playing games, going bowling, playing baseball, softball, and tennis, or going camping. Over time, using leisure in our spare time has changed. Swimming in the Tittabawassee, Chippewa, Pine, and Tobacco Rivers has given way to swimming pools. Ice skating on farm fields where snow and ice covered the harvest stubble has given way to heated indoor ice arenas.

Sheer abundance as well as an increase in population has changed our leisure and the way we pursue it. More things seem to be organized. Do kids ever play softball in a vacant lot anymore? Do any of us go for a walk and just daydream for a change? William Shakespeare once wrote: "A light heart lives long." We all need a time for a little leisure. Here are some pictures, some old, some not so old, to remind us of how we once spent our leisure time.

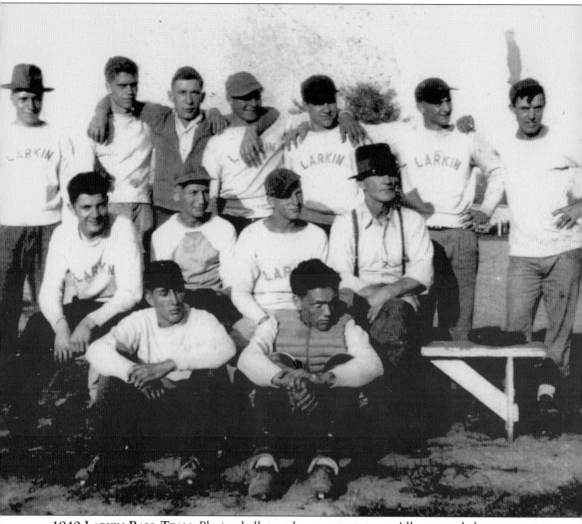

1940 Larkin Ball Team. Playing ball was always a great sport. All you needed was a vacant field, a ball and bat, and enough guys to make a team. Here is the Larkin ball team as they looked in 1940. Pictured from left to right are the following: (front row) Rollie Piegols and Lorin Speaker; (middle row) George Blackhurst, Johnny Prewozniak, Bud Howe, and Warren Howe, manager; (back row) Norman Oliver, assistant manager, Norman Kaweck, Fritz Oliver, Emil Sapyak, Steve Balcirak, Ed Capyak, and Walter Tucker.

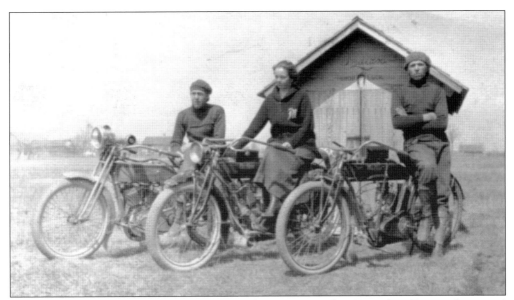

THREE OF A KIND. This picture is dated April 16, 1916, Larkin Township. During the period between 1905 and 1925, motorcycles became a passionate new hobby with both men and women. The first motorcycle in America was a gasoline-engined bicycle made by Oscar Hedstrom in 1899. In 1900, it was displayed at Madison Square Garden in New York to pace bicycle racers. It was there that George Hendee saw the new contraption and thought it had a future.

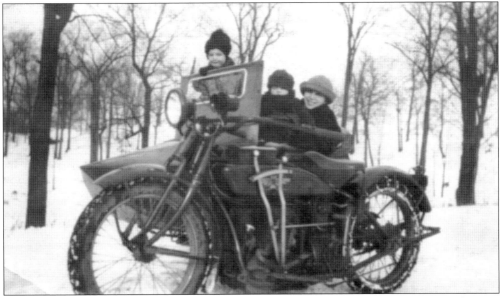

WINTERTIME ON A MOTORCYCLE. The popularity of motorcycles was phenomenal. Even children went along with their parents on these new machines. The first motorcycle by the Hendee Manufacturing Company was produced in 1901 and named "Indian." Just three were made that year, but in 1916, 41,000 Indian motorcycles were manufactured and sold. In 1903, the Harley-Davidson hit the market as competition for the Indian. But by 1925, the motorcycle boom was ending with the popularity and availability of automobiles.

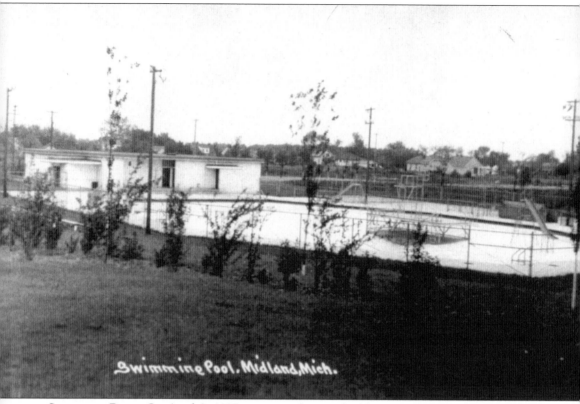

Swimming Pool, Midland, Mich.

SWIMMING POOL. On April 8, 1937, voters said yes to building a swimming pool in the new Central Park. Free swimming and lessons were offered in the morning, but swimming in the afternoon cost a nickel. The water seemed awfully cold in the morning, but in our family we had the choice of swimming in the morning—or not at all! Having your own swimming pool was only possible if you were a movie star or incredibly wealthy. Therefore, the local outdoor swimming pool was well used in the summertime. A lifeguard sat in something almost like a tower with a chair on the top and signs read: "Deep water." By the end of summer, everyone was tanned from the sun and water combination.

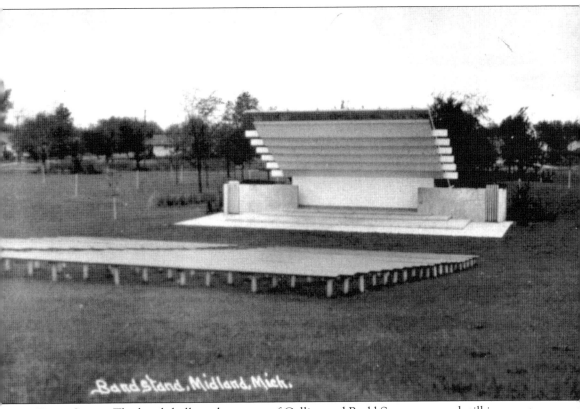

Band Stand, Midland, Mich.

BAND SHELL. The band shell on the corner of Collins and Rodd Streets was and still is a great place to listen to the city band on a summer evening. Designed by Alden Dow, the only real changes today are new benches and much larger trees! When it was under construction, the area was wet and swampy, and the neighborhood kids made rafts from old wooden scraps and poled around in the puddles. Ted Nicholson was the first director of these popular city band concerts, which were held on Wednesday evenings from the very beginning. Ted also had a long career as the band director at Midland High School. In more recent years, the musical tradition begun by Ted Nicholson was carried on by Bob Ralston to the delight of the loyal audiences who attended the concerts. For over half a century, Midlanders young and old have enjoyed these musical summer evenings in Central Park.

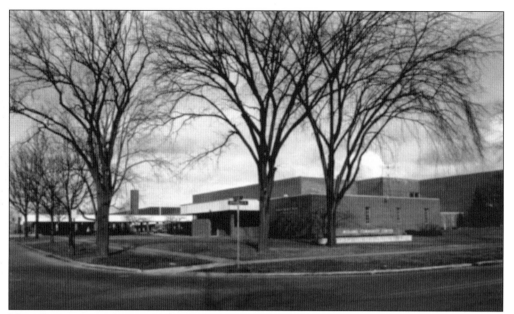

NEW COMMUNITY CENTER. This is the new Midland Community Center located on George and Jefferson. The first community center was located on Townsend Street next to the Carnegie Library. Tap-dancing lessons went on side-by-side with basketball games. But Midland grew, and in 1955, this new building became part of our town, and dancing and basketball games still continue there. (Photo courtesy of *Midland Daily News*.)

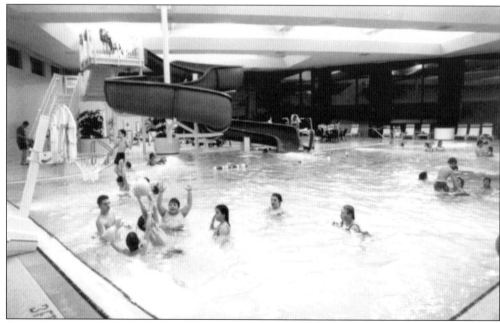

SWIMMING INDOORS TODAY. This is the swimming pool at the Midland Community Center with slides and heated water. Not only do families enjoy times together in the pool, but specific programs have been added for therapeutic purposes, and regular water exercise programs are held. (Photo courtesy of *Midland Daily News*.)

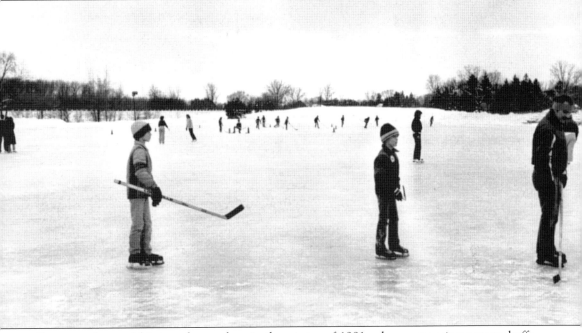

SKATING AWAY. This is a photo taken in the winter of 1981, when some winter sports buffs braved the weather to try out the city's newest ice skating pond at Currie West Golf Course. In the 1940s, Emerson Park was where all the kids met to skate and spend time together. Inside Currie Stadium was a place to warm up and put our skates on. Music was played over the sound system, one of the favorites being "The Skater's Waltz," of course. This was a wonderful excuse for the older boys and girls to skate together while the younger kids raced in and out. "Crack the Whip" was a big favorite, as long as we didn't get too rowdy and arouse the attention of the guy in charge. (Photo courtesy of *Midland Daily News*, Glenn M. Roberts.)

Currie Municipal Golf Course. Currie Municipal Golf Course came into existence because of Gilbert A. Currie Sr.'s determination that a golf course should be available to anyone wanting to play golf. As long as he was the president of the Midland Country Club, he insisted that anyone could play on the golf course by paying a token fee of $20 each season. When Currie resigned as president in 1947, members rescinded that rule. Currie then turned his attention to planning his second golf course: an 18-hole municipal course. He chose 257 acres of land in a flood plain where homes had been removed. In the process of changing the bend in the Tittabawassee River, tons of dirt were excavated, and Gil Currie saw to it that this dirt was placed on what would be the new golf course for the people of Midland. In 2002, the golf course was enlarged and a new club house was built. (Photo courtesy of *Midland Daily News*, Glenn M. Roberts.)

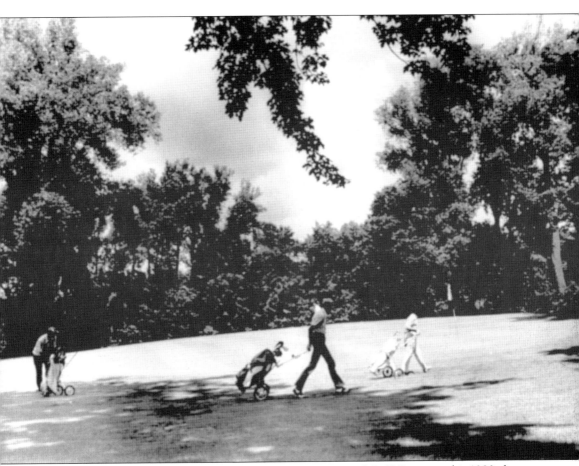

GOLFING AT CURRIE. Golfers stride across the Currie Municipal Golf Course in this 1980 photo. On September 2, 1952, work on the new golf course had begun, and Currie himself supervised. (He left his law practice in the care of his son to pursue his passion: building a municipal golf course for the city of Midland.) Currie and his workers drained swamps, moved trees, hauled in dirt and turf, and on October 1, 1953, Currie announced that the new municipal golf course had been completed and would open in the spring of 1954. By the time the grand opening was held in May of 1954, a new club house and parking lot were ready, too. Currie died in 1960 at the age of 77. Katherine Tuttle wrote in 1958 in the *Midland Daily News*, "Deep within us all is the need to give, yet few achieve wise giving." Fortunately for the city of Midland, Gilbert Currie achieved that wise giving. (Photo courtesy of *Midland Daily News*, Glenn M. Roberts.)

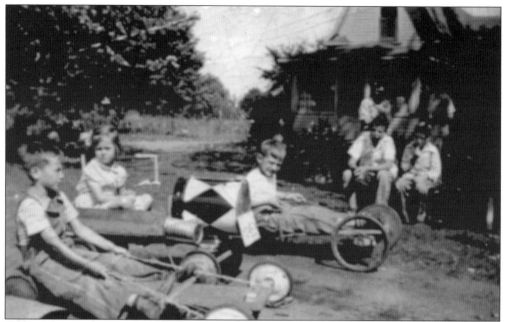

SOAPBOX RACING I. Once upon a time, kids had to amuse themselves in the summer months, because there were no television shows or computer games to occupy spare moments. Boys tended to think up things like soapbox racing. You'll note that a girl is also in the picture and she has the fanciest car, complete with a license plate.

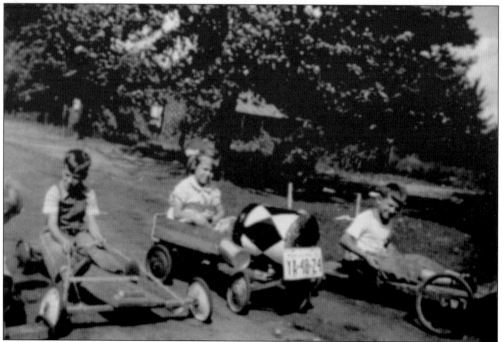

SOAPBOX RACING II. All a kid needed was some old wagon wheels, something to make a seat out of, and a rope to tie to the two front wheels. Then one child was the pusher and another the driver. Soapbox races could keep a kid occupied for days, if not weeks.

Six

MOTHERS AND FATHERS
OUR PAST

The role of men and women was fairly well defined in the first half of the last century. The man's duty was to provide for his wife and children. Sometimes he was a farmer. Sometimes he was employed outside, meaning that he worked at The Dow Chemical Company, or at the chicory plant or at the cheese factory (one in Edenville and one in Coleman), at Austin Construction, or at the new place out on the road to Freeland: the Dow Corning Company. Some became professional men such as doctors and lawyers. His labor paid for a home, a horse and buggy (later, a car), groceries, clothing, and once in awhile some entertainment. To be a good provider was the highest accolade a man could earn in a time that was less complex that what we know today.

Most women, then, had a different role than their husbands. They cooked three meals a day, cleaned house, did the washing, hung clothes out to dry, ironed, mopped linoleum floors, dusted furniture, sewed, provided basic first aid to family members, and raised the children. When asked if they worked, they replied, no, they stayed home. Being a mother and a wife was considered a full-time job and most women embraced the role readily. To keep an immaculate house, to be a good cook, to raise children to be responsible adults, and to be a helpmeet for her husband were considered the loftiest ambitions that a woman could have. Her role as a wife and mother dignified her in all strata of society.

Looking back at that time not so long ago in our history is to marvel that the men and women lived up their calling with such grace and fervor.

ELMER (BUD) SCHARTOW JR. "On Sundays we visited relatives in Saginaw and Mother seemed to have a penchant for leaving her purse behind when we left Saginaw. The trip home usually included a stop at the ice cream parlor on State Street in Saginaw. I remember her sitting on the back porch with her apron on and cutting up string beans for canning. She'd usually do that while listening to Harry Heilman narrate the Detroit Tigers ballgames on the radio."

ELMER (BUD) SCHARTOW JR. "Dad had a habit of falling asleep in the large leather chair. Many times he did that with a burned-out cigar butt in his mouth. Sometimes Mother would remove the cigar when he got to snoring, but other times—a sudden inrush of air and the butt would end up in Dad's mouth, which then woke him as he tried to wipe cigar ash off his tongue."

CHERYL DEMSKI SPEAKER. "I remember as a child getting up every Sunday morning to be at the 6:30 a.m. Mass at St. Brigid's. The whole family had to go together. Dad listened to no excuses. If you couldn't get up for church then the next week you went to bed earlier. After Mass we always went to the gas station Dad owned on the Circle. While Mom and Dad closed out the books for the week, my brothers and sister and I would play in the station. After that, we all went home for a big Sunday breakfast. When Dad got into boat racing, every weekend we were somewhere on the banks of a river camping in a tent. At the time I hated it, but now it's one of my favorite memories."

FRANCES NOLD OLIVER. "This is my mother, Agnes Swallow, and my father, Martin Nold, on a picnic before they were married. They were married on December 22, 1921. Picnics continued to be a special event for my parents and for their three children (Wilma was my older sister, and Ernie was my brother) as well. Especially when we went berry picking in the woods or fishing at a lake. And I smile when I remember the times when my mom and dad and all of the relatives would get together and have potato pancake suppers and good ole fish frys. I have some very special memories of my mom and dad."

SUE GORDON KIMMEL. "My mother was a teacher and my father was a farmer. I remember after the corn was husked, the stalks were raked into rows in the fields and burned on a still night. It was a glorious sight with the fields alight with fires and I would look through the wavy lines of heat as they rose from the burning cornstalks, struck by how beautiful something so simple could be."

DOROTHY RAETZ AND KAREN PROVOST. "Edith Asch met Bill Burke, her future husband, while she was working at the Stag Hotel in Midland. Her co-workers dared her to put salt in his coffee. He stormed out of the restaurant but later asked her for a date. After they were married she said to her new husband, 'I didn't think you would ever speak to me again after I put salt in your coffee.' Bill answered, 'I got even with you—I married you.'"

BARBARA PREWOZNIAK. "This is my father, Bill Haley, with his bride-to-be, Blanche Auriela Fry. I remember the time I wanted new roller skates and was told I would get a pair as soon as my dad got a raise. I told all the neighbors that as soon as Dad got a raise I would get new skates. The next week when I had my new skates, all the neighbors came by and said, 'I see Bill got a raise.' When I was 9 or 10 I saved half the money to buy a bike. Dad took me to Wenzel's and the bike was more than I thought it would be. Bill dickered with Albert Wenzel and finally got the price down until I had enough for my half and I said 'Okay.' On the way home my dad told me if I had kept quiet we could have bought it for less!"

BARBARA HALEY PREWOZNIAK. "This is my mother, Blanche Auriela Fry. Born August 21, 1891, at the end of the Victorian era in our history, she died on October 31, 1979, having seen a man walk on the moon in her lifetime. She attended Midland County Normal in 1908, taught school, and eventually married a young man named William Martin Haley. When World War I ended, Blanche bundled up her first child, Margaret (Maasberg), and put her in a buggy. Then they walked downtown to the (old) Midland Courthouse on Main Street where everyone was gathered because World War I had ended. Blanche was obviously a stylish young lady, and her hat in the picture is styled in the fashion of Broadway's Flora Dora girls."

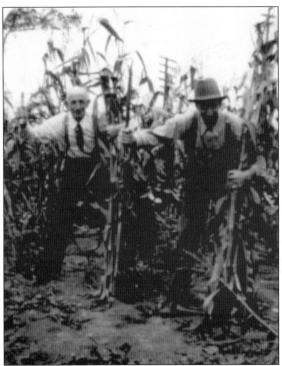

MARTHA RANCK. "Pa (Edward DeJongh) and his brother John show how corn was cut in the early 1900s. In 1920, 20 acres of their farm was put into sugar beets. While Pa and brother Carl loaded and hauled the beets to town, my four older sisters pulled and topped the beets. Like many farm families, we missed the first two months of school to help harvest the crops that would feed the family and animals for another year."

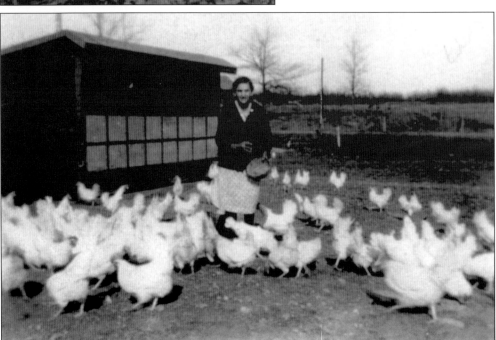

MARTHA RANCK. "Ma's (Iva DeJongh) favorite part of farming was her chickens. She had 500 white leghorns and six chicken coops that she kept meticulously clean. She put fresh straw in for the chickens each week and if you couldn't find Ma, you just walked out by the coops and listened for humming. She always hummed when she was working with her chickens. We loved the fresh eggs and fried chicken on Sundays."

JOHN EDWARD SPEAKER. "My mom was Clara Schneider but everybody called her Tootie. Once I heard somebody call her Clara and I didn't know who they were talking about. My dad was Lorin Speaker. I was their first child and the first grandchild in the family. I grew up with brothers and a sister, lots of cousins. Everything else took second place to the family."

RUTH STELLMACHER LYTLE. "I remember sitting on Dad's lap to listen to the Lone Ranger on the radio. Mom made a rule that he could never chew tobacco in the house. He had to go outside or in the garage. My mom was very quiet, and would only sing when she ran the sweeper but she had a beautiful voice. This is my mom and dad, Hattie and Otto Stellmacher, when they were 60 years old."

PATRICIA HANDLOVITS. "My memories of Dad (Max Barr) always bring fishing to mind. He loved to fish and usually our family outings involved fishing in one way or another. We spent a lot of pleasant evenings fishing, picnicking, and playing at Dad's secret fishing hole near the Edenville Dam. When we went to the Lumberjack Picnics we saw log rolling contests with lumberjacks competing to see who would stay on the log the longest. Towards evening we would get out glass jars and try to capture the lightning bugs as they flitted about. When Dad got back from fishing we let the fire die down and then it was time for marshmallows toasted in the burning embers. It was the end of a perfect day. Dad had one of the first television shops in Midland and we would sit and watch a little round television with such poor reception you could hardly make out what was going on. But it was new and we thought it was wonderful."

JUDY SHOOK KRUEGER. "I remember Mom bringing some baby chicks in the house and putting them in a laundry basket by the heat register to warm them and revive them. They had been stepped on by the hens. After my dad died, Mom was still young and she began traveling. She surprised all of us! We never thought of our mother as being adventurous."

JUDY SHOOK KRUEGER. "I have so many good memories of my dad, Ray Shook. He started working in grocery stores right after high school and then had his own store. First he called it Shook's General Store, then Ray's Shopping Center, and finally Shook's Self-Service Market. At the end of the day, he would sit in his chair at the dinner table sideways, almost too tired to eat."

CAROL HOERNEMAN PLAUSH. "The best memories I have of my dad are at the table eating a meal, any meal! He would sit at the end of the table across from my mother. Whenever we had company, which was often, he would begin the meal by telling some outlandish story, get well into the meal, then slip in, 'By the way Christine (my mother), this is the best meal you've ever made!' It made us all laugh to see him enjoying himself and it made Mother feel good for her efforts. Dad lived to be 97 and Mom and Dad were married 70 years. He was a good role model for his grandchildren. This picture is one of the 'after Chandler Presbyterian Church dinners' in 1946, with all three generations of the Conkey, Wakefield, and Walker families represented. Christine Conkey is on the far left with me sitting on my grandma's lap. Hal Conkey, patriarch of the family, is on the far right."

Seven

DAGLE'S CORNERS
THE CIRCLE

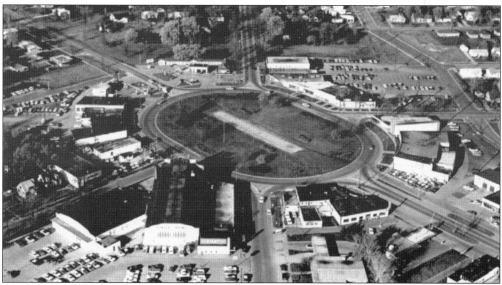

In 1932, the Midland city limits ended where the Community of Christ Church stands now. Snake Creek meandered from the Country Club on Eastman Road through Barstow Woods and the area of Nickels Street, Lingle Lane, and Richard Court. The creek and the vacant land were little incentive for commercial development, and it was considered too far out from the small town of Midland, Michigan, to be of much use commercially. This was the area that was originally platted by a young man named Anthony Dagle, giving it the name Dagle's Corners before it was renamed the Circle.

By 1932, Leo Solosky and his wife had a grocery store and a gas station "out there." In 1937, Jess Mudd opened up a combination grocery store and gas station on property purchased from Henry Schultz on the opposite corner of Solosky's store. In 1942, the Midland Theatre opened for business. Eventually they were joined by Smith's Flowers and Gifts, Otway Autos, the Circle Grill, Emily Gibbs Children's Store, Miller Furniture, Del's Drive Inn, Knopic's Hardware, the Giant Super Market, Demski's Hi Speed Station, and a branch of the Chemical Bank.

Today the Circle is in the center of things with Saginaw Road going through it, and the people who saw a future in Dagle's Corners were right.

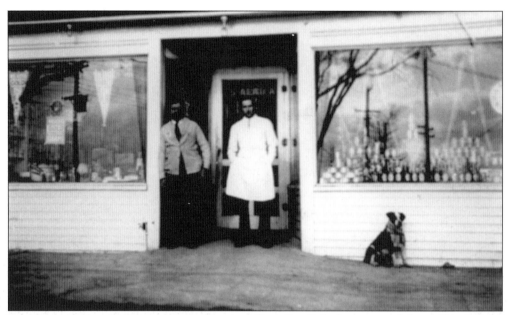

Leo Solosky, Larry Dundas, and Rex the Dog. Leo Solosky poses with Larry Dundas, the meat cutter, at his relocated store on the Circle after the new highway went through. Leo and his sons also ran the Sugar Bowl, an ice cream store by the grocery store. Every day Rex walked over to the Sugar Bowl for an ice cream cone.

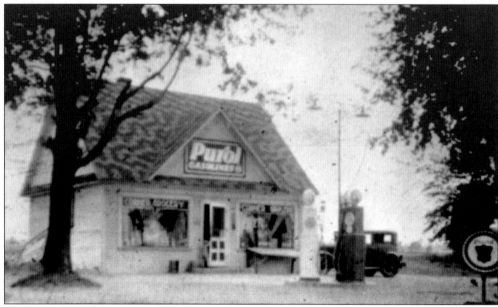

Solosky's on the Circle. Today we know it as Saginaw Road and it runs through the Circle, but in 1932 it was called U. S. 10 and there was no Circle. The city limits ended just before you reached the Circle. Leo Solosky owned a little grocery store there, and his brother Frank had a small gas station.

PURE OIL STATION. Pictured here is the Pure Oil Station, which was owned and operated by Harry Demski on the Circle in Midland for many years. Harry also operated another station on Saginaw and Eastman Roads and built the business he named Northtown Rental and U-Haul on Eastman Road before retiring. Today, a clock shop and shoe repair shop occupy the space where his station once stood.

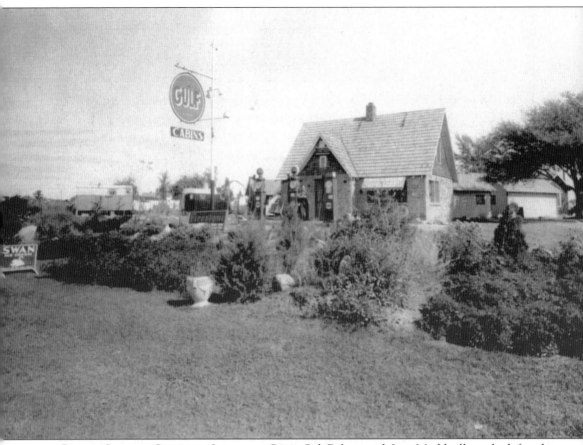

CIRCLE SERVICE STATION. Lawrence Cote, Sid Baker, and Jess Mudd all worked for the Dennison Oil DX Station on Ellsworth in downtown Midland originally. In 1937, the chance to buy the Henry Schultz farm came up and the three men decided to go into business. U.S. 10 went through the area, but there was no Circle as yet. Jefferson Road was called State Road where U.S. 10 split the street, and it was made of gravel, not pavement. Dutch Cote owned two-fifths of the business, Sid Baker owned two-fifths, and Jess owned one-fifth with the provision that Jess would operate the new grocery store and gas station. This is how it looked in May of 1938, complete with overnight cabins and lots of shrubs. When business didn't take off, Charlie Dennison went out to take a look and told Jess to cut the shrubbery down. It worked!

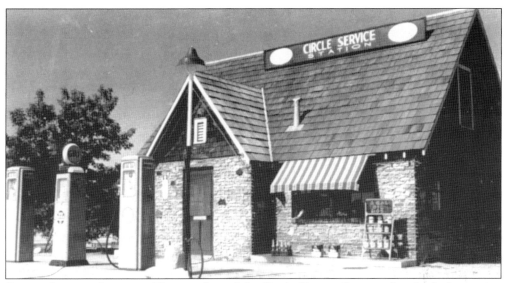

CIRCLE SERVICE STATION. This is a shot of the Circle Service Station after the little wooden cabins had been replaced by brick ones. The five tourist cabins were named for the Dionne quintuplets: Emilie, Marie, Annette, Yvonne, and Cecelia.

1943 TAYSTEE BREAD PROMOTION. Jess Mudd poses with the young women helping to promote their product. At the left you can see one of the five little tourist cabins named for the Dionne Quintuplets. Duane remembers that groceries were stored in the second story, and a space heater was used for heat in the store in the early 1940s. Jess not only sold groceries, he also delivered them if asked to do so.

GRAND OPENING. This photo shows the front of Smith's building facing Ashman, c. 1956. Notice that the sign identifying the building as Smith's hasn't installed yet. One of the first businesses on the Circle, it is one of the top 175 FTD florists from 20,000 florists across the country. (Photo courtesy of *Midland Daily News*.)

SMITH'S INTERIOR. Designed by Alden Dow in the 1940s, the interior of Smith's in Midland shows the famous fish pond as well as the sweeping curves of brick and plaster walls and built-in display tables. Always innovative and ahead of their time, a coffee shop is to be added around the fish pond. (Photo courtesy of *Midland Daily News*.)

THREE GENERATIONS. Here are three generations of the Smith family, proud owners of one of the most distinguished stores in the Midland area. Pictured from left to right are the following: Mark Smith, current president; Donald L. Smith, former president and owner; and Mark's two sons, Michael and Mark. Today Smith's Flowers and Gifts carries on the proud heritage begun when Rolland and Bernice Smith and their son, Don, opened up a small florist shop on the Circle in 1948. Later they moved to their present location in one of the first retail stores designed by Alden Dow. The modern interior has a fish pond that has remained a stellar attraction through the years, especially for the children. Over the years, Smith's has done it all. They were selling Sony Stereos before anyone else knew the name. Furniture, linens, china, sterling silver, and fresh flowers and plants have made Smith's a household name in the Midland area. (Photo courtesy of *Midland Daily News*.)

OTWAY AUTOS. For the last half-century, a sign on the Circle in Midland has read "Otway Autos." Today, there are few businesses on the Circle as old as Don Otway's. Originally, Don Otway and Stan Bobit leased the property owned by Bartlett and Asch. He says, "I didn't know if I'd be here 30 days, at the time." In 1958, Don bought out Stan Bobit's share of the business, and a couple of years later, he purchased the property from Bartlett and Asch. Of his half-century in business, Don says, "I have met many wonderful people in Midland." And he's still selling cars at the same location! (Photo courtesy of *Midland Daily News*.)

CIRCLE BOWLING. Eventually the Midland Theatre closed its doors. Television had taken away movie audiences temporarily. Circle Bowling went in instead and bowling leagues soon filled the alleys. Pictured here is Ed Gibson, who managed the bowling alleys for Delores Cassidy, widow of Bill. (Photo courtesy of *Midland Daily News*.)

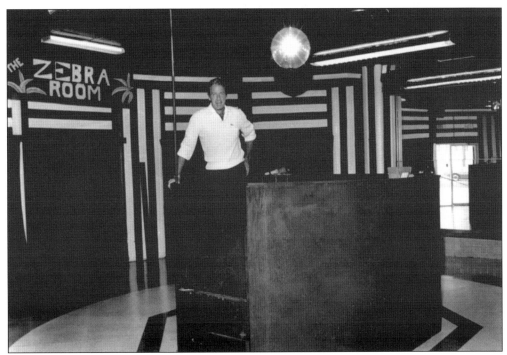

THE ZEBRA ROOM. Business ebbed and flowed on the Circle, as recessions followed by boom periods occurred over the course of the past 50 years. At one time, the Zebra Room was a calling card for people who wanted some entertainment. (Photo courtesy of *Midland Daily News*.)

THE MIDLAND THEATRE. Bill Cassidy owned both the Mecca and Frolic Theatres on Main Street in Midland when he decided to take a leap of faith and build a new theatre on the Circle. The Midland Theatre opened May 23, 1942, and its opulence was quite unfamiliar to Midland at the time. After buying your ticket at the front entrance, you walked into an elegant, red plush carpeted foyer and saw top-of-the-line movies. The first was *Captain of the Clouds* starring James Cagney. Midlanders stood in line for hours for the grand opening and everyone decided that Mr. Cassidy's $300,000 had been wisely spent on the new complex. However, the first reaction of some people in Midland was, "Who's going to drive way out there to see a movie?"

Eight

THE CHANGING FACE
OF MAIN STREET

When we were young, Main Street seemed to remain the same for years and years. By the time we were eight years old, we were adept at naming the businesses that lined Main Street. Everything was within walking distance. You could start at one end of Main Street and pay your light bill, grocery shop, buy furniture, shop the dime store, buy the family's clothing, go to the bank, see a movie, buy an ice cream cone, and see the doctor or dentist. It was convenience personified! If Main Street changed a store, we didn't notice it until we got older, and then we wondered how it had happened. Where did Cunningham's Drug Store go? Where was J.J. Newberry's Five and Dime? When did they put a new dime store in where the Frolic Theatre had been for so many years? At the time, we thought the change came suddenly, but in retrospect it wasn't sudden at all. It happened one store at a time, one year at a time. Main Street wasn't Main Street anymore, but then, we weren't eight years old any longer either.

AL DICKEY SALT WORKS. After the 1892 explosion at the Larkin and Patrick Saw Mill, the mill was never completely rebuilt. Al Dickey continued a salt and bromine business for awhile, but by 1900, the brine was being diverted to the Dow Chemical Company and eventually all of these buildings disappeared. A parking lot took over.

FARMER'S MARKET. Today the Farmer's Market stands where an old parking lot once stood. It is hard to believe today, but this site on the Tittabawassee River bank was at one time a neglected part of Midland's downtown area. The early Farmer's Market was simply a matter of small vegetable stands, but today it's a place where Midlanders flock to enjoy open-air shopping and camaraderie.

ASHMAN SOUTH OF MAIN. This is a view from the corner of Ashman and Main looking toward the river. If you remember when Ashman looked like this, you're an old-time Midlander. On the banks of the Tittabawassee River, it was first the city dump. The area was neglected until a parking lot was put in. Railroad tracks crossed at the foot of Ashman and the old depot was still standing.

ASHMAN, SOUTH OF MAIN TODAY. Can you believe you're looking at the same place? The riverfront is now a scenic place for picnics and various celebrations. The Tridge and Chippewassee Park with its skate park are popular with Midlanders and visitors. Carl Gerstacker's vision of changing the riverfront has come to fruition.

MIDLAND'S FIRST COURTHOUSE. Henry Ashmun (Ashman) was given the responsibility of selecting the site for the new courthouse to be built in the Village of Midland City. Henry went on horseback to Lansing, the new capitol of Michigan. Once there, he persuaded them to give the prosecuting attorney of Midland County and the supervisors of Midland County the authority to select the location. Since Mr. Ashmun was both the prosecuting attorney and the only supervisor, he chose the spot where he also owned the land. On October 13, 1856, the stake was driven marking the site for the new courthouse. On hand for the occasion were Billy Vance, Joseph C. Townsend, Charles Fitzhugh, E.G. Buttles, H.M. Ellsworth, Dan Davis, Timothy Jerome, and Mr. Ashmun. Construction began in 1857, and the courthouse was ready for occupancy in 1858. In 1872, Supervisor L.F. Smith of Lincoln Township asked that the county seat be removed to Averill Station in Lincoln Township. The resolution was tabled and remains so to this day.

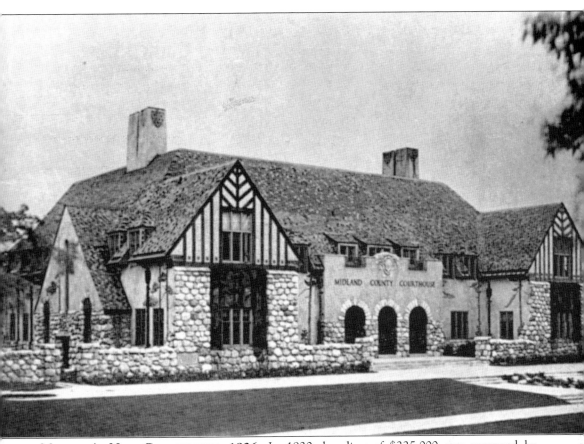

MIDLAND'S NEW COURTHOUSE, 1926. In 1920, bonding of $225,000 was approved by the voters of Midland. Dr. Dow offered to assist if he were given permission to use his ideas regarding the type and construction of the new building. Bloodgood Tuttle, an architect from Detroit and Cleveland, was selected to design the modified Tudor-style building. Paul Honore, a Detroit artist, was hired to do the murals. Don Gibb of The Dow Chemical Company worked with Paul Honore to perfect a new material for the murals so they would be weather-resistant. Andy Arbury posed for the woodman in the mural. On New Year's Day of 1926, the new courthouse became home to Midland County employees. The Midland courthouse is historically significant because there has been continuous county government activity on the same block since 1858, when the original frame building was erected.

FIRST FROLIC THEATRE. The first Frolic Theater opened on October 19, 1921, on the corner of Gordon and Main. Horatio Foster owned the corner first and had a funeral parlor and furniture store there. Then the Knights of Pythias had their temple there. When the temple burned, Bill Cassidy bought the land and put his second theatre up. In 1928, the Frolic was wired for sound movies.

NEW FROLIC THEATRE. Bill Cassidy and his wife, Delores, lived above the theatre. The tall addition on the back of the building was built to accommodate the equipment for sound movies and the scenery for Friday night vaudeville shows. In 1940, *Gone with the Wind* came to the Frolic and tickets were $1.10 instead of the usual 25¢. The Frolic Sweet Shop was next door and was always open after the movies had ended.

WOOLWORTH'S DIME STORE. After the Frolic Theatre burned and was torn down, the property was purchased by the Woolworth Company and a new dime store was put in. This was a welcome addition to Main Street, since the J.J. Newberry Five and Dime had closed. In addition to the usual items carried by dime stores in those days, it also had the attraction of a great lunch counter.

THE MACKINAC CENTER. The corner of Gordon and Main has evolved greatly over the past 150 years. Now the corner is occupied by the Mackinac Center, Midland's very own "think tank." This business is a welcome addition to Main Street, one which has aesthetically enhanced its corner of the street.

MIDLAND POST OFFICE, C. 1918. W.D. Gordon sold his Main Street property for a new post office, which was built in 1918. This post office was razed in 1939 and replaced by a new one on the same property. A temporary post office was set up in the Baker Building until the new one was ready for business.

ASHMAN COURT HOTEL. Today the Ashman Court Hotel occupies the block that once had the post office and the J.C. Penney Company. Now a branch of the post office is located in downtown Midland, and the main post office is on Rodd Street. J.C. Penney is now in the Midland Mall. The first hotel in many decades in Midland, the Ashman Court Hotel, has added to the ambience of Main Street.

108

1948, THE CORNER OF MAIN AND ASHMAN. In 1948, Alden Dow came up with the idea of lining Main Street with trees. The city council approved the planting of four Moline Elms on Main Street between Ashman and McDonald. In this photo, a tree is being planted near the corner of Ashman and Main. Stark Nursery was paid $125 per tree installed, and the Herbert and Grace Dow Foundation provided $1,000 to finance the experiment.

2002, THE CORNER OF MAIN AND ASHMAN. 101 Main Street and Pizza Sam's now occupy the corner where the tree planting took place in 1948. 101 Main is a popular eating spot with outdoor café seating in the summer. Pizza Sam's, one of the earliest pizza parlors in Midland, moved to this location from their original location on the corner of Main and Benson Streets.

W.R. KNEPP & COMPANY. Knepp's, on Main Street next to Wenzel's Hardware, was one of the better department stores in Midland. We shopped at Knepp's because we could always find what we wanted, and best of all, we could take the merchandise home on approval. (This was an important advantage in the days before credit cards!)

KNEPP'S BLOCK. Today a number of locally-owned shops thrive in the old Knepp's and Wenzel's area. Various small shops include the Apothecary Shoppe, Mid-Michigan Music Shop, the Jock Shop, and Jack's TV. Names of stores may change, but customer service remains the same. It's great to still have mom-and-pop stores.

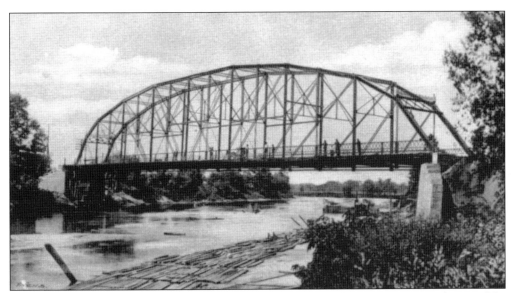

BENSON STREET BRIDGE. When the original wooden bridge, built in 1872, was destroyed by the flood of 1907, the new Benson Street was built in its place. This bridge provided access to Main Street from the Fourth Ward and the Bullock Creek area until the Mark Putnam Bridge was built connecting Poseyville Road to the downtown area. The loss of the smaller bridge limited pedestrian traffic to Main Street until the Tridge was built.

RIVERSIDE PLACE. This senior citizens' complex was built on Main Street at the same Benson Street location. If you go to the back of Riverside Place, the old cement abutments are still visible. In addition to comfortable living quarters and assisted living, the residents are close enough to enjoy the activities of the downtown area.

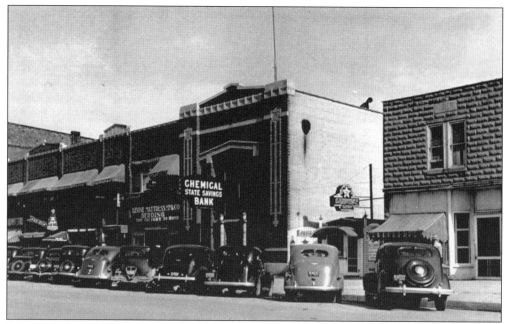

CHEMICAL BANK. This picture, taken in the 1930s, shows the Chemical State Savings Bank on Main Street in Midland. Next to the Chemical Bank was the popular Star Sandwich Shop, and the striped awning denotes the Arndt Bakery. On the other side of the bank were the Levine Mattress Company, the Arcade Building, and the Grigware Music Shop. Doctors and dentists had their offices on the second floor of these buildings.

NEW CHEMICAL BANK. Chemical Bank opened March 14, 1917, at 333 East Main Street. The address remains the same today, but now encompasses the area of the old community center and Carnegie Library on Townsend Street, and several of the old stores on Main Street. The Chemical Bank & Trust Company has been a driving force in maintaining the integrity of Main Street.

112

Nine

BOUNDARIES OF EDEN

Trust the happy moments, The days that make us happy make us wise.
—John Masefield

There was glory in being a small child growing up in a small town in the middle of the last century. On Sundays, families got together to visit. The men talked about ball games, cars, and their jobs. Women gathered in the kitchen to cook and talk about babies, housework, and the latest gossip in the neighborhood as they stirred the lumps out of the gravy and mashed the potatoes. As children, we were expected to be "seen" and not "heard," which made for a lot of leeway. It meant we could play outside and pretend to be the Lone Ranger and Tonto. We could be Prince Valiant or Morgan LeFey or Aleta, Queen of the Misty Isles. If the weather was too cold to play outside, we would play Old Maid, Checkers, or Dominoes inside, all the time yelling at our little brothers and sisters to leave us alone. Fathers worked and mothers stayed home. Meals were served three times a day, and everybody sat down at the table together. Milk bottles could be traded at the neighborhood store for a nickel. Attendants at the gas stations pumped the gas for your car, checked the oil, the tire pressure, and cleaned the windshield and a dollar's worth of gas could last a week. A dollar could also buy two adult and five children's tickets to the movies. Extended families were the norm: aunts, uncles, cousins, and grandparents were all considered "family." None of us growing up in those times realized it, but we were living in a sort of Eden.

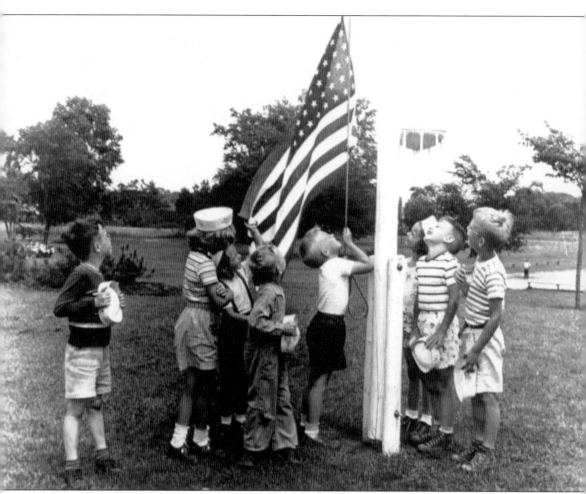

DAY CAMP IN MIDLAND. As the Midland Community Center grew in size and expanded its programs, summer day camps were added for school-age children. The morning routine began with the raising of the American flag, and everybody recited the Pledge of Allegiance together. Then we broke up into groups and went with the young men and women who were the leaders of the summer camp program. When we went home, we played "camp" all over again, but this time we were the leaders and our younger brothers and sisters were the children we taught. The last day of camp was celebrated by inviting all the parents and brothers and sisters to join us as we demonstrated our new skills. This ended another season of camping.

BY THE SEASHORE. Swimming in the summertime was the best of all possible worlds. Your mother said you had to wait an hour to give the sandwiches and watermelon time to get out of your stomach or you would get a stomachache. Swimming in August was out of the question because a strange new disease called Infantile Paralysis could strike if you went swimming.

AN AVERAGE DAY. Your dad worked in the yard while your mother was in the house doing the dishes, cooking, ironing, and taking care of the multitude of chores that kept every woman occupied from morning to night. Your mother's interest in the yard was to plant the flowers and water them. Your dad raked, hoed, mowed, and sometimes when he was done, he would say, "Do you kids want a ride in the wheelbarrow?"

FIVE-MINUTE COWBOYS. It's hard to believe, but people once made a living by taking shetland ponies around small towns so that kids could have their picture taken riding a pony. Boys especially liked posing on a horse. In their imaginations, they instantly became Red Ryder, Gene Autry, Lash LaRue, Hopalong Cassiday, Roy Rogers, or the Lone Ranger, just by being lifted up on the back of a shetland pony. After the man with the shetland pony left town, the cowboy persona lingered on and the game of Indians and Cowboys went on endlessly with the kids in the neighborhood. It was even better if you had a cap gun and a holster to swagger around in. Caps were small dabs of special gunpowder, about the size of a ladybug, deposited between two layers of paper. They exploded with a loud bang when struck, and some kids could make them explode by running their thumbnail across them very fast.

SHARING A HORSE. Farm horses were versatile; they plowed fields or provided entertainment for visiting grandkids. The number of children who could be seated on the back of a horse depended on how big or little the kids were. If you squeezed in, you could always add one more. Nobody asked the horse how it felt about having its picture taken.

TWO ON A HORSE. Relatives with a horse or a shetland pony were well worth a ride in a hot, stuffy car on a summer afternoon. Your dad or grandpa dutifully lifted you up so you could sit on the back of the horse (minus a saddle, of course) and then your mom or grandma would say, "Hold still while I take your picture."

MERRY-GO-ROUND. Every summer, a carnival or a circus came to town. Local boys were hired by the traveling circuses and carnivals to help set up tents and get the rides going. There was a ferris wheel, a tilt-a-whirl, and a merry-go-round. Cotton candy, hot dogs, and ice cream cones were sold. Young men tried their prowess at throwing balls at milk bottles or shooting wooden ducks with a B.B. gun. Men went to view the livestock. Women looked over the canned goods and the 4-H projects. Fair time had something for everybody! When we were little, our parents took us along to enjoy the fair; when we became teenagers we were allowed to go by ourselves. Over all of the din of the fair was the sound of the music of the merry-go-round.

THE GREAT PRETENDERS. Movies were a great impetus in our lives, and we loved to pretend that we were the characters in the latest movie that we had seen. Gender roles were flexible. A boy could be the Fire Goddess as well as a girl. And likewise, a girl could be a circus impresario. Imagination was our link to another world that we glimpsed briefly each time we paid a dime to see a movie at the local theatre.

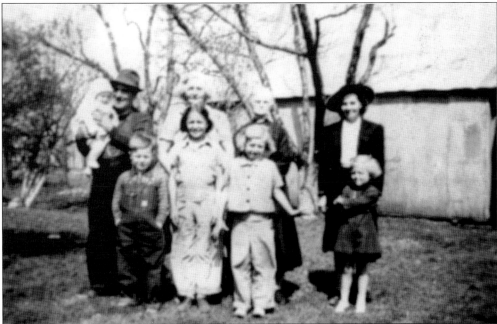

SUNDAY VISITS. Sunday wasn't Sunday if you didn't get in the car and go for a ride—usually to visit relatives. Communication hadn't become instantaneous yet. There were no computers, no cell phones, no chat rooms. If you wanted to chat with someone, you had to visit with someone face to face—or at least on the telephone. And not everyone had a phone.

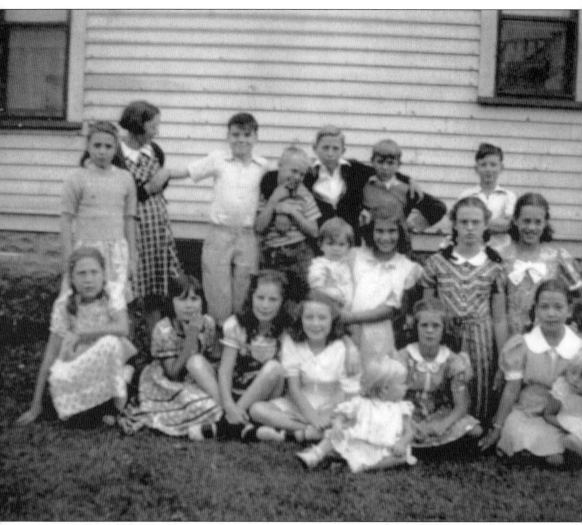

BIRTHDAY PARTIES. Once upon a time there were no Chuck E. Cheeses or McDonalds where kids went to celebrate their birthdays. Instead, your mother baked a cake and you invited all the kids in the neighborhood. Some simple games like Pin-the-Tail-on-the-Donkey and Musical Chairs were played. After the birthday cake and ice cream were served, you opened your gifts which were small and inexpensive but treasured nevertheless. When your dad got home from work that day, he said, "Well, Babe, how did your birthday party go today?" Kneeling in front from left to right are the following: Ruth Stellmacher, Bette McAnallen, Norma Rifenberg, Maxine Frizzle, Arlene Gooch, and Nancy Gauss. In back of Ruth is Bonnie Baldwin, and behind her is Margaret Frink. Clark McLaren is wearing a big smile, and Cecil Rogers has his arm around two unidentified boys. Leona Clark is holding her baby brother; Bill Morgan is in back of her; and Dorothy Gooch is in front of Bill. We don't know the girl with the pigtails or the two little girls in front.

COOLING OFF! Summers got hot just as they do now, but there was no air conditioning unless you counted an electric fan on the floor that blew the hot air around. Swimming pools weren't available, but mothers improvised. The tin wash tub was filled with water and set on the lawn for us to jump into. There's nothing like sitting in a tub of cold water on a hot summer day!

NEIGHBORHOOD CHILDREN. Our worlds were defined by the neighborhood where we lived. We were all one-car families, and our dads took the family cars to work each morning, so we played with the neighborhood kids. We played house, kick-the-can, eeny-eye-over, upset-the-fruit-basket, tag, softball, and hop-scotch in the summer. In the winter we made snow angels, snow forts, had snowball fights, and flopped on our stomachs on our sleds.

PICTURE TIME. Meet Miss Wagon Wheel of 1935! In that far-off time, little girls could pose in the barest of necessities without danger of being censored. Of course she had to have on shoes and anklets. Children were indulged, loved, scolded, spanked, and adored by parents and grandparents and grew up in a cocoon of family care.

NEIGHBORHOOD CIRCUS. Entertainment wasn't made for us. We made our own entertainment. And one of our favorite ways to entertain ourselves was to make up a circus. Costumes were put together from odds and ends that we begged from our mothers. Eventually everyone was ready to perform and you invited all the family to watch the performance. Prices were reasonable. One or two pennies were the standard admission fee.

SANDLOT BASEBALL. Every neighborhood had an empty lot that could be converted quickly into a baseball diamond. All that was necessary for a game was a bat, a ball, and enough kids to make two teams. Sometimes the boys were benevolent and let the girls hit "grounders." The pitcher rolled the softball on the grass up to the batter who had the bat resting on the home plate ready to "hit" the ball.

EASTER SUNDAY. Regardless of how limited the family budget was, new clothes for Easter were a necessity. Little girls usually had their hair curled and wore silk panties, underskirts, and dresses topped with a sweater or a light coat and a hat. Shoes were either made of patent leather or saddle shoes. Little boys had fresh haircuts and were dressed in miniature adult male attire—trousers, white shirt, necktie, and jacket.

SUMMER BOUNTY. Gardens were the pride of every grandmother. Her garden was weeded, hoed, and watered all summer long to make sure that when August and September came, there would be a bountiful harvest of things to can. We loved the taste of a tomato warm with the summer sun, but heaven help us if we stepped on the vines!

GRANDFATHER AND GRANDSONS. Grandfathers were an inexhaustible source of wisdom, enjoyment, and love. They were wise. "Don't swallow a watermelon seed or you'll have a watermelon grow in your stomach." They let you ride in the rumble seat of the car so the wind could blow in your face. They took you with them when they went to the woods to cut kindling wood. They smelled like wood smoke, Red Man Chewing Tobacco, and red flannel shirts.

GEESE READY FOR MARKET. Sitting in an apple orchard on a crate of geese made for a great opportunity to take a photograph. It seemed that most grandparents lived on farms. We watched as cows were milked, helped gather eggs, begged to ride the horse, and walked behind our grandfathers as they plowed. Grandparents made a child feel special and loved in the world that we grew up in.

NATURE'S AIR CONDITIONING. Summer in the 1930s meant spending lots of time with cousins. When the weather got hot and patience wore thin, Mom would pile everybody in the car and take us to the bend in the river for cooling off. (Swimming pools were in the distant future.) After sloshing around in the seasonally warm water, we were ready to go back home and everybody was on speaking terms again.

SUCCESSFUL FISHING SISTERS. Camping was really camping. We had a tent and a few basics like blankets and pillows, cooking equipment, and a charcoal grill that took forever to get going. You fished and swam and went in a boat with your dad while your mother stayed by the tent, sitting in a dark green cloth folding chair and catching up on her reading. Every time we went, we said it was the best vacation we had ever had.

TWO FOR THE ROAD. If there was anything more wonderful than getting your own bike, no boy over eight years old could think of it! And it was even better if your friend had a bike to ride along. Having a bike opened up a whole new world. You didn't have to rely on walking. Now you could get someplace in a hurry because with a bike you had speed!

THE SNOWPANTS KIDS. Winterwear wasn't meant to be fashionable. It was meant to be warm and practically indestructible. Snowsuits were made of wool. They came in three colors: dark blue, dark green, and brown. They were durable enough to last through two or three kids in the family before they were discarded. Scarves, mittens, and rubber boots that left marks on the back of your legs completed the outfit.

TONTO AND THE LONE RANGER. Tonto and the Lone Ranger were the enduring heroes of our childhood. They appeared weekly at the local theatre in a serial that ended in a cliff-hanger. Miraculously, each time they both escaped to entertain us for another week. After we were grown up we heard the *William Tell Overture* and recognized it immediately. It was the music for the Lone Ranger!

THE ENDLESS SUMMER. When we were young, summers were endless and wonderful. From the day school got out in June until it started after Labor Day, the whole summer stretched before us! You woke up to hot weather and went to bed with hot weather. Screened doors slammed open and shut all day as you went in and out of the house. Your mother froze orange Kool-Aid in the aluminum ice cube trays and said you had to eat them outside because they melted on the kitchen floor. Sometimes your mom would let you sleep on the floor in front of the screen door. She spread blankets on the floor and then plunked pillows down. You all got into bed and your mom spread a clean sheet over you and an Indian blanket (it got chilly during the night). Then your dad would come to say goodnight and he'd smile and say, "Look at you. Snug as a bug in a rug!"